Hans Van de Bovenkamp
Large Scale Sculptures
Fountains & Gates

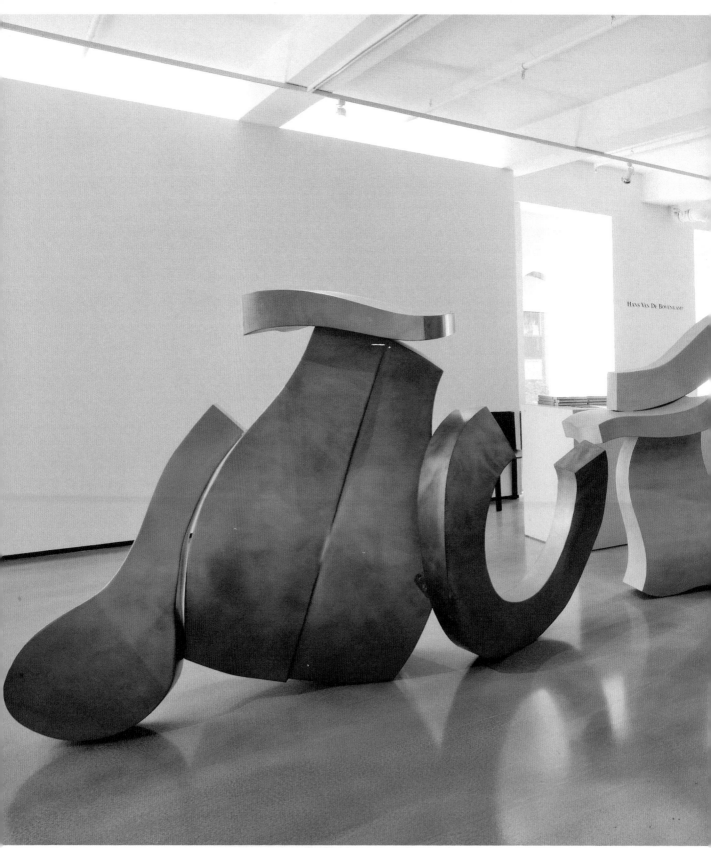

As exhibited at the Bernarducci.Meisel gallery in NYC 2011

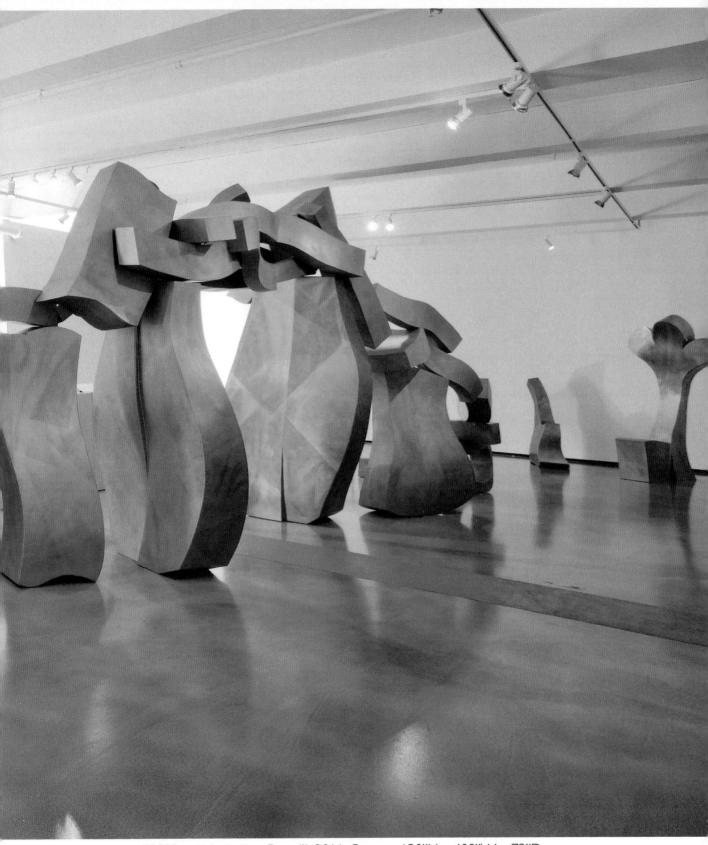

#0002 • "Manhattan Portal" 2011 Bronze 120"H x 408"W x 72"D

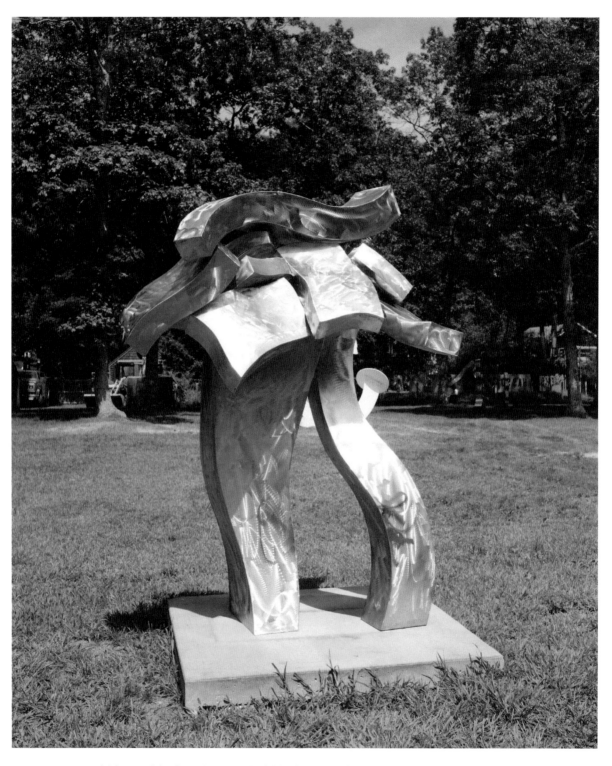

#0001 • "Oh, Ophylia, Why" 1989 Stainless Steel 96" H × 60" W × 36" D

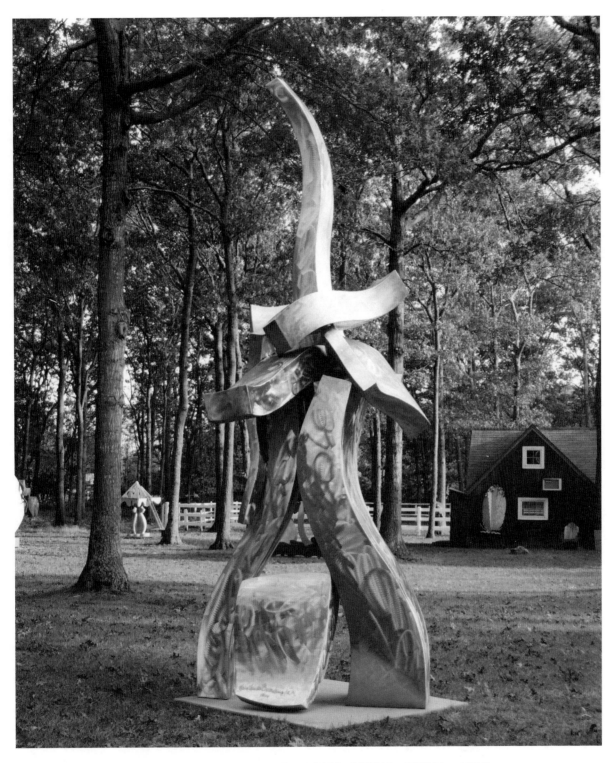

#0004 • "Spire" Stainless Steel 2008 192" H x 72" W x 60" D

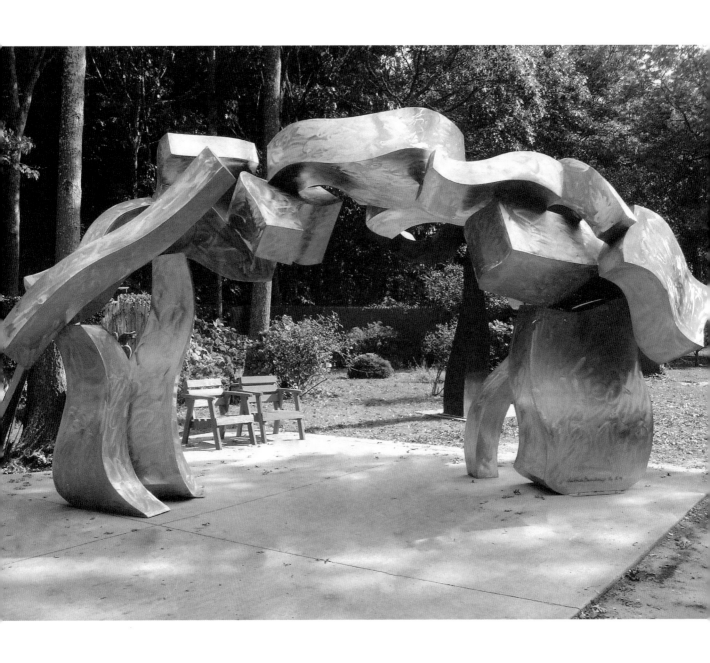

#0006 • "Sagg Portal" Stainless Steel 2009 144" H × 288" W × 72" D

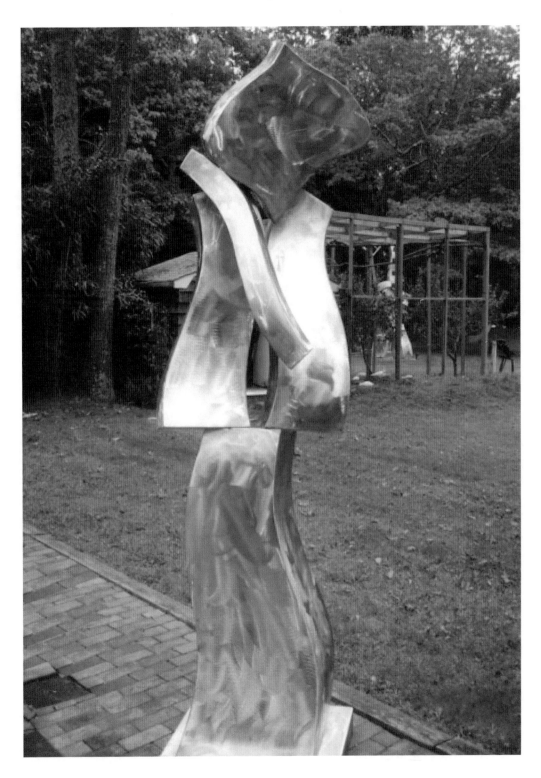

#0010 • "Muse#3" 2008 Stainless Steel 96" H x 24"W x 24"D

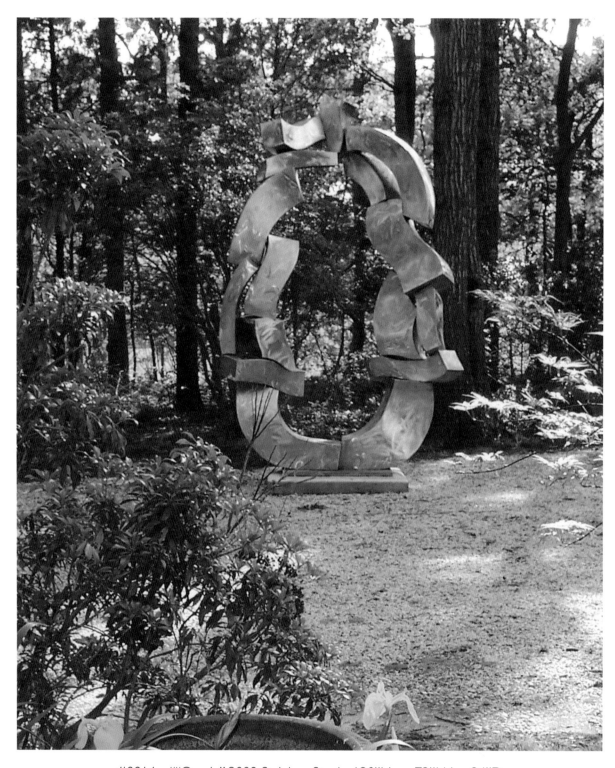

#0014 • ""Oracle" 2008 Stainless Steel 120"H × 72"W × 24"D

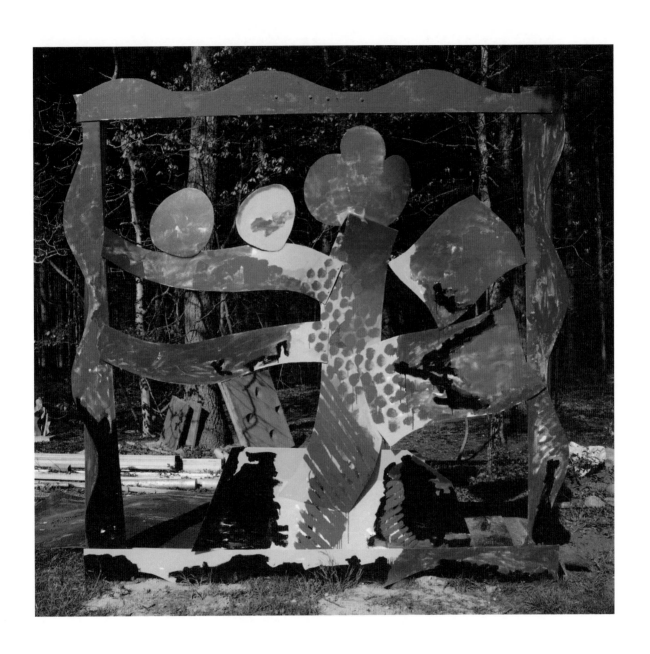

#0018 • "Ode to Karen Appel" Painted Aluminum 2006 96"H x 120"H x 12"D

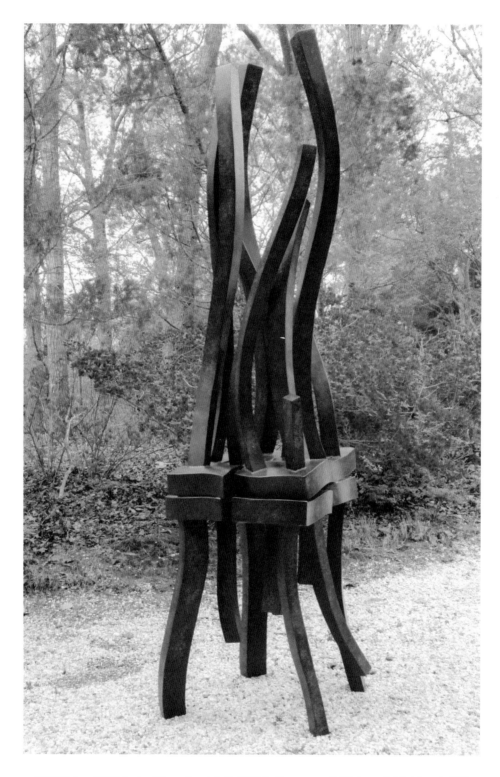

#0022A • """Ode to Chamberlain" 2006 Bronze 96"H x 24"W x 24"D

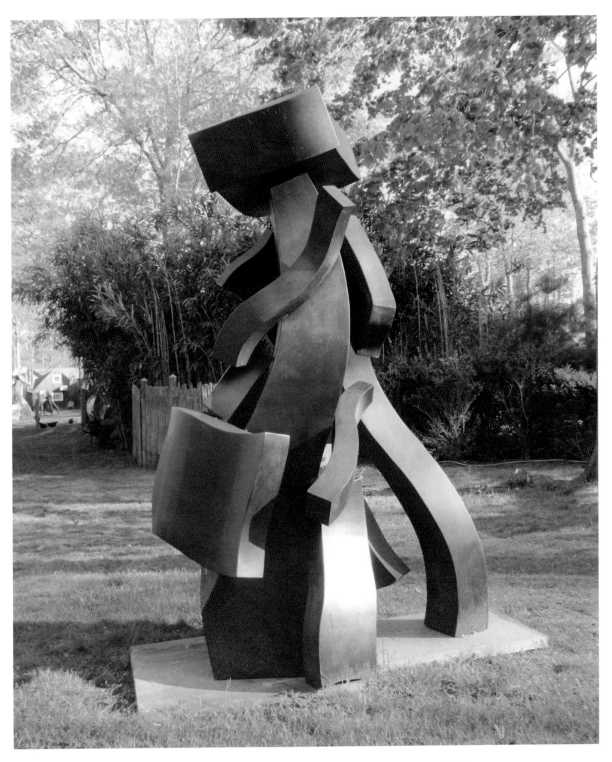

#0023 • "Gaea" 2012 Bronze 95" H x 60" W x 45" D

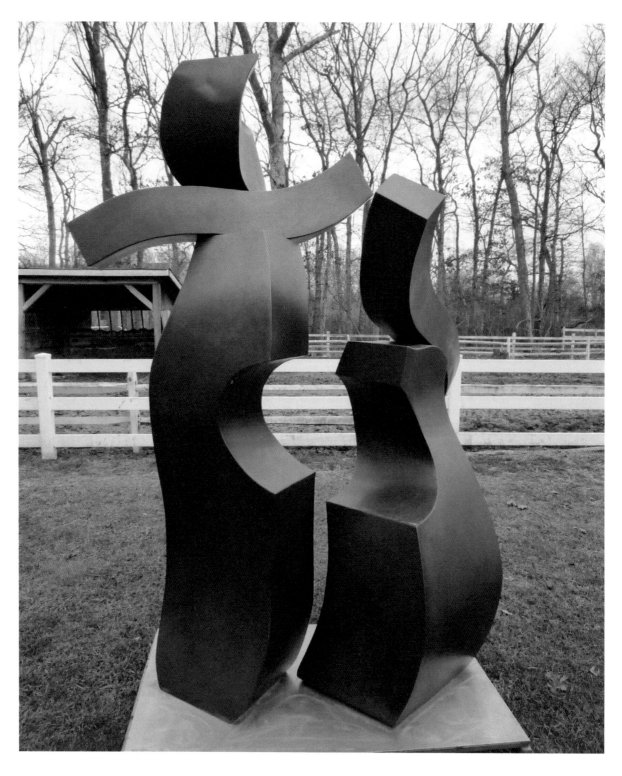

#0024 • "Izanagi & Izanami" 2006 Bronze 99" H x 78"W x 46"D

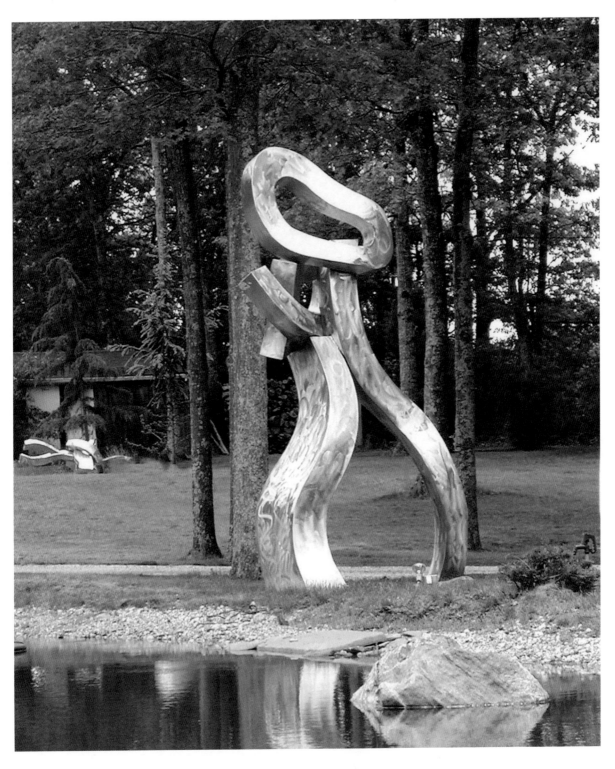

#0027 • "Ode to Miles" 2006 Stainless Steel 180" H x 96" W x 84" D

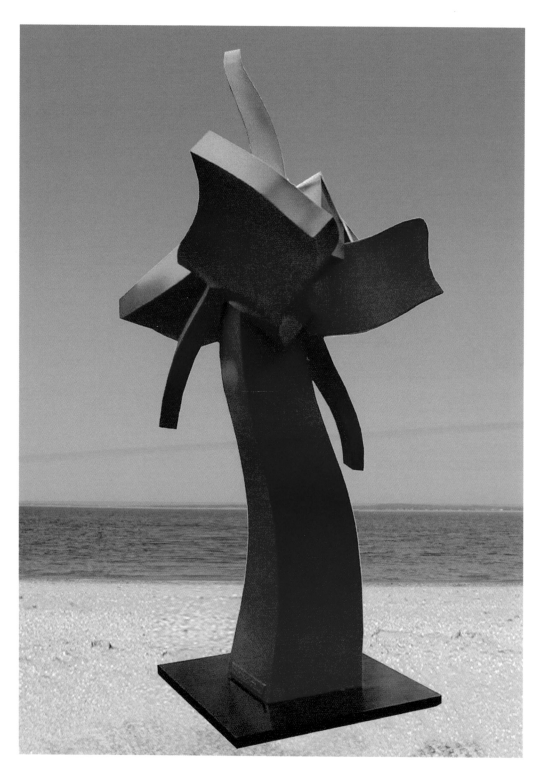

#0036 • "Olympia" 2006/2007 Painted Stainless Steel 144" H x 60" W x 48" D

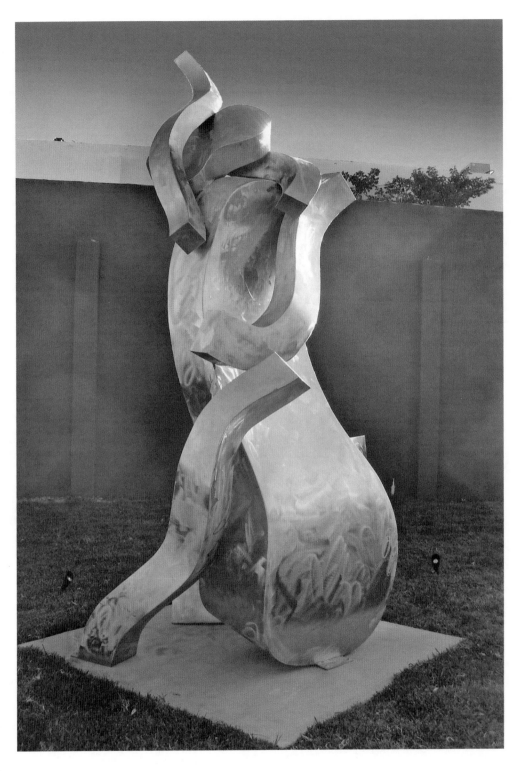

#0037 • "Ode to Charles Mingus" 2005 Stainless Steel 168" H x 84" W x 60" D

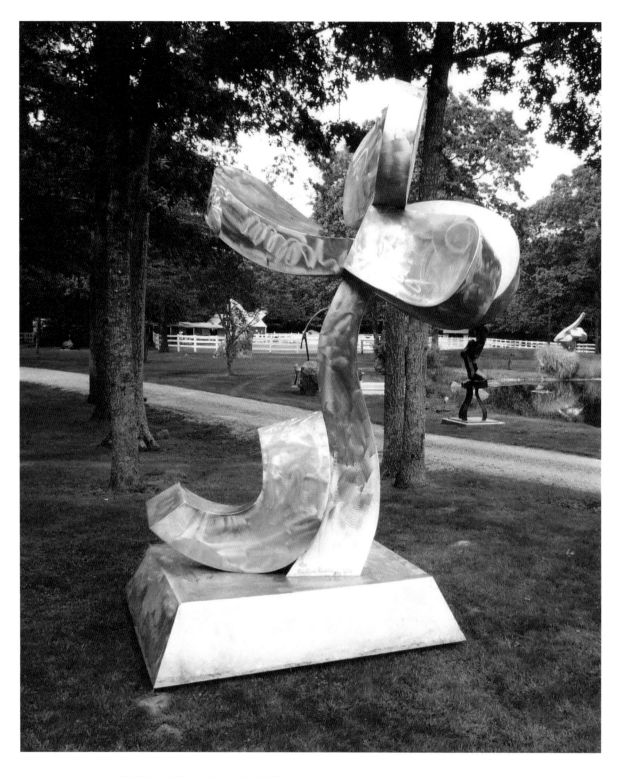

#0038 • "Cloudkicker" 2005 Stainless Steel 128" H x 79"H x 97"D

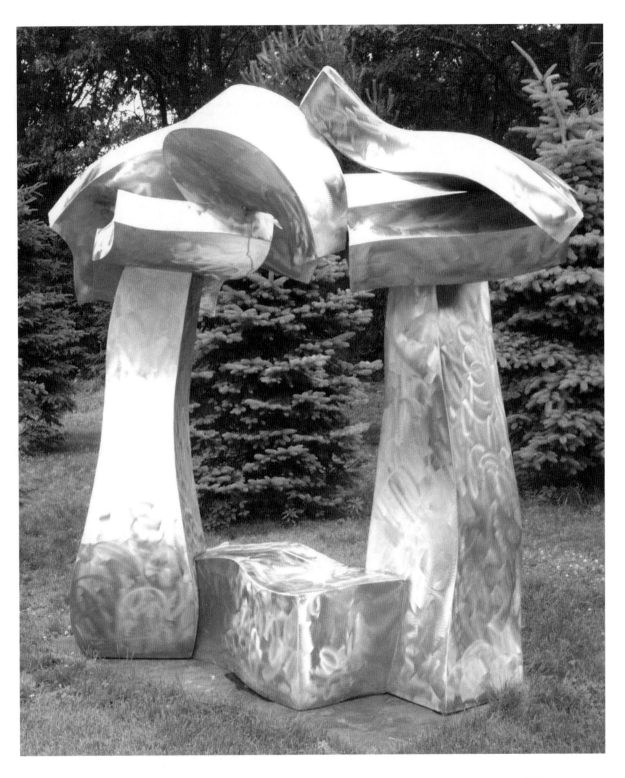

#0046 • "Sagg Portal with Bench " Stainless Steel 2006 108" H x 120" W x 60" D

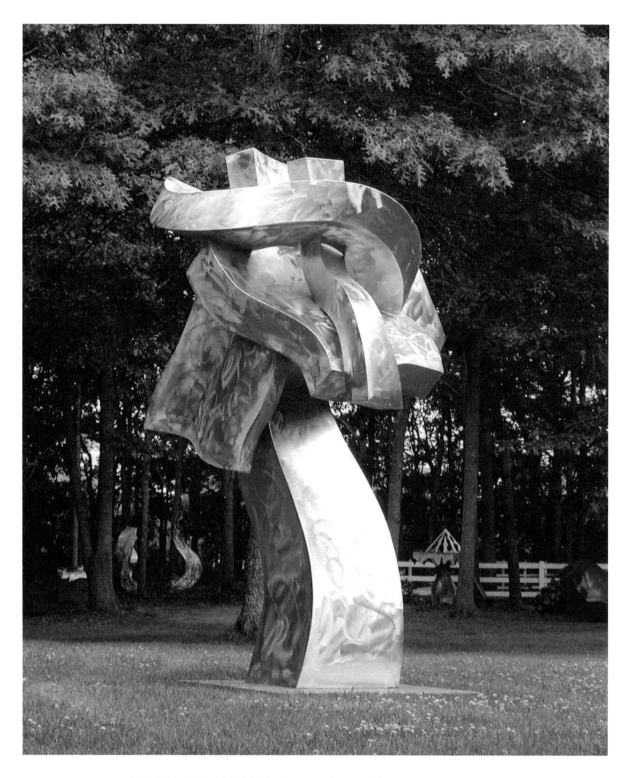

#0047 • "Seive 2" 2004 Stainless Steel 120" H x 72"W x 74"D

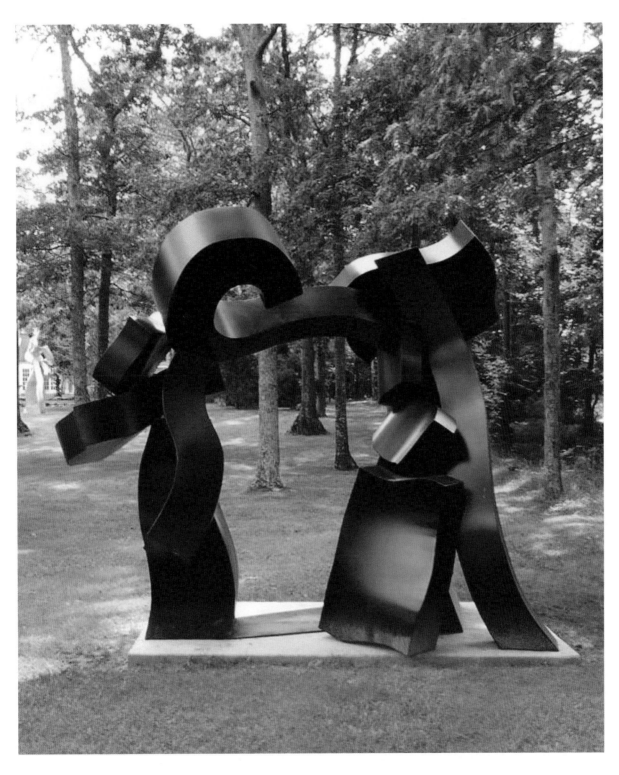

#0071 • "Black Portal" Painted Stainless Steel 2009 125" H x 140"H x 78"D

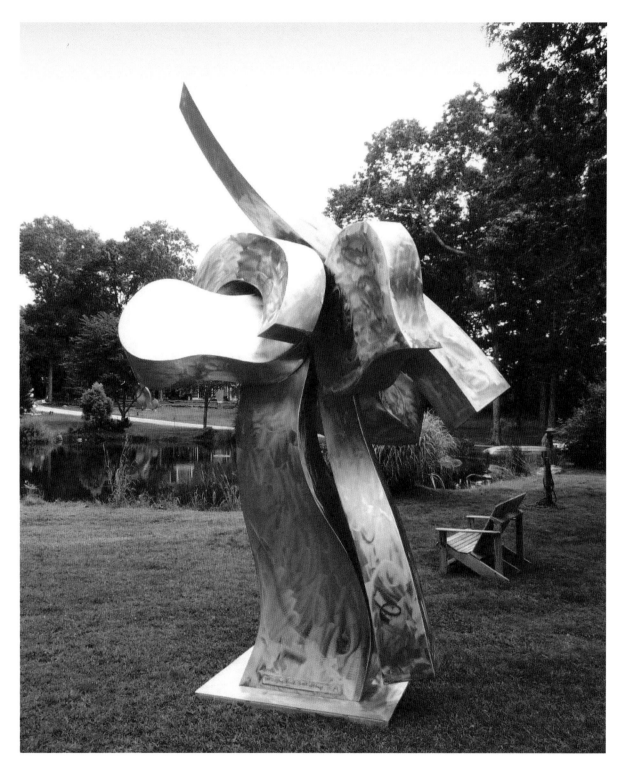

#0072 • "Menhir Meneer" 2009 Stainless Steel 148" H x 94"W x 86"D

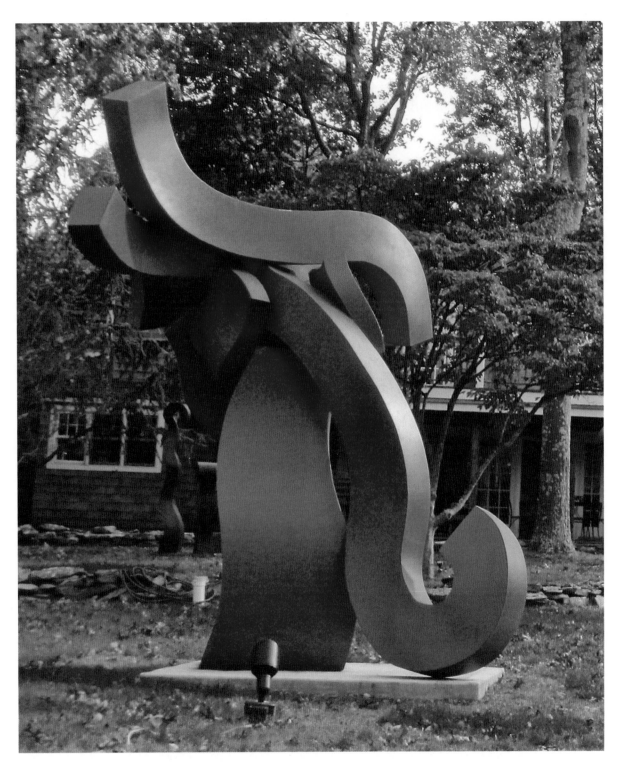

#0073 • "Red Trunk" 2009 Painted Stainless Steel 150" H x 112"W x 104"D

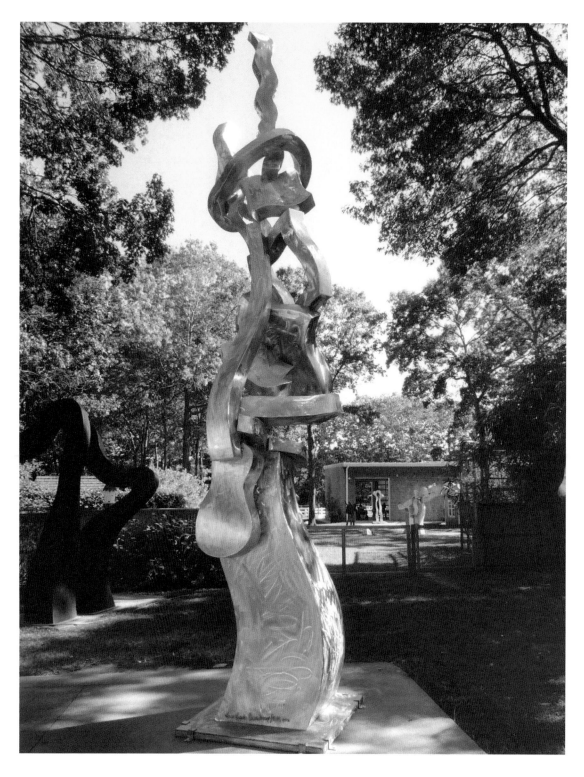

#0075 • "Menhir Tower" 2010 Stainless Steel 180" H x 48" W x 48" D

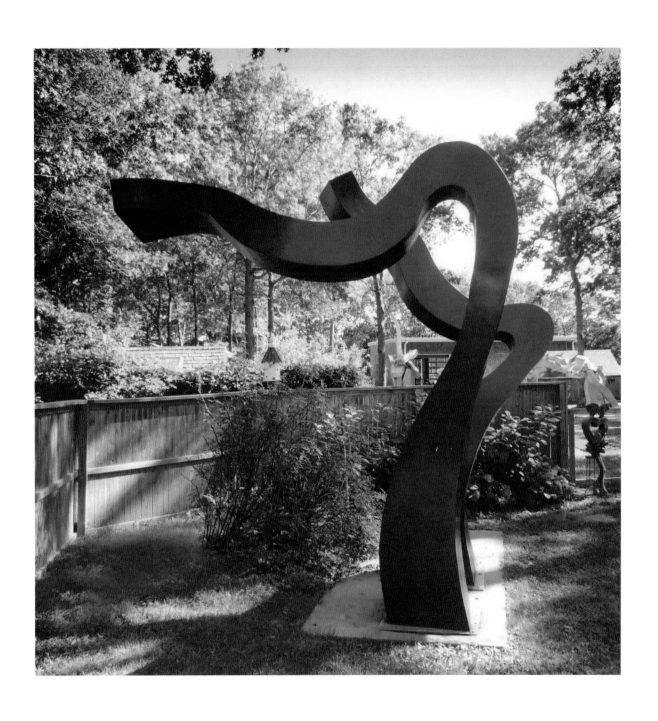

#0082B • "Stela in the Wind" 2009-2011 Bronze 138" H x 120" W x 72" D

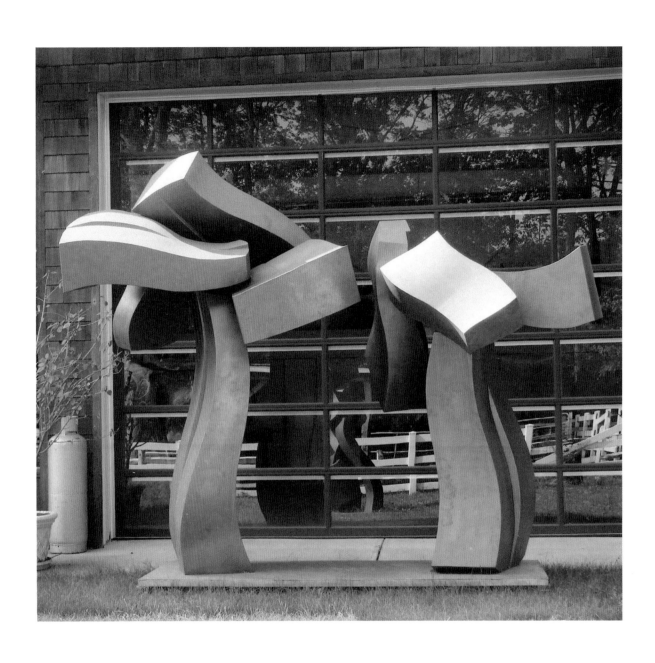

#0085 • "Spirit Portal" Bronze 2009 132"H x 192"W x 72"D

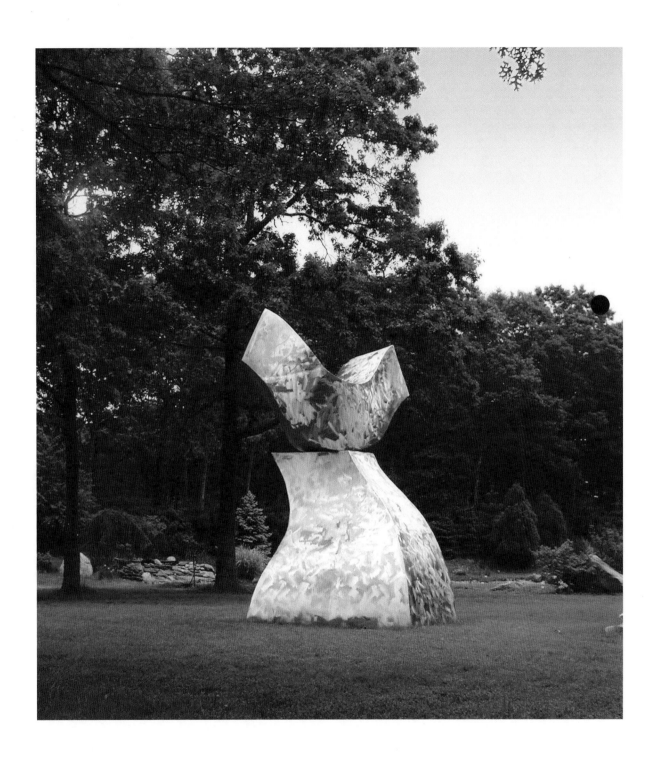

#0087 • "Stargazer" 1989 Stainless Steel 144" H x 96" W x 65" D

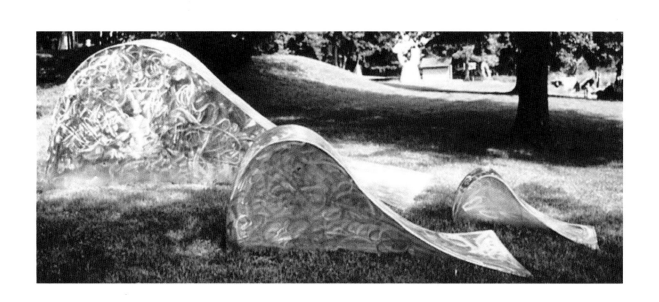

#0088 • "Waves and Whales" Stainless Steel 2011 60" H x 96" W x 216" D

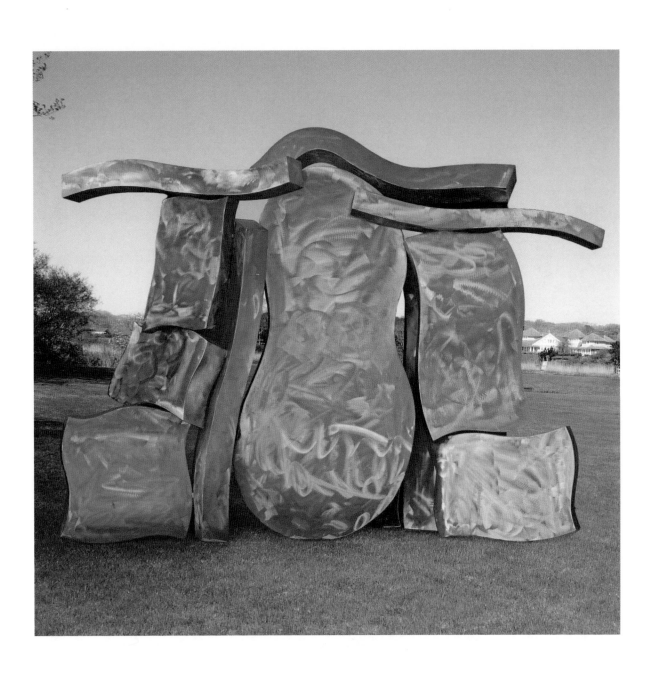

#0095 "The Beloved" Stainless Steel 2011 84" H x 120" W x 72" D

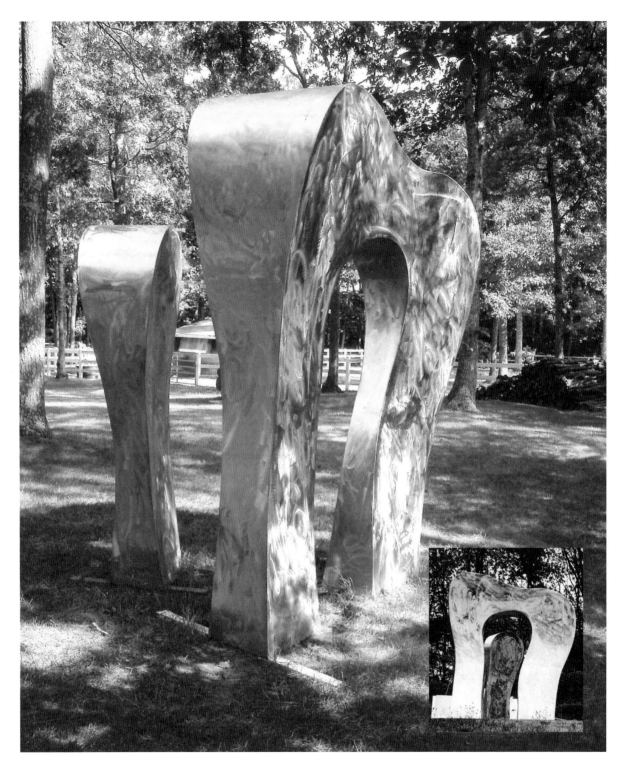

#0099 • "Doorway" Stainless Steel 1999 96" H x 72" W x 72" D

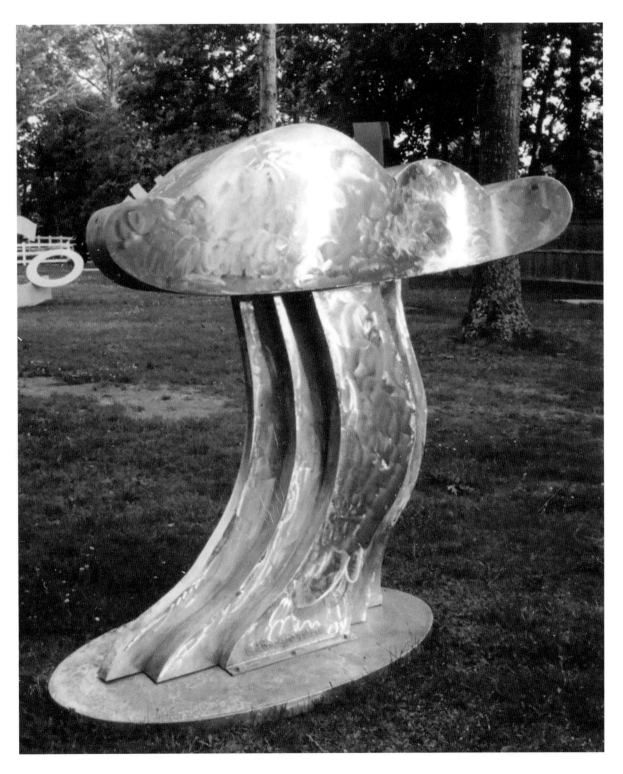

#0100 • "Cloud" Stainless Steel 1999 72" H x 69" W x 39" D

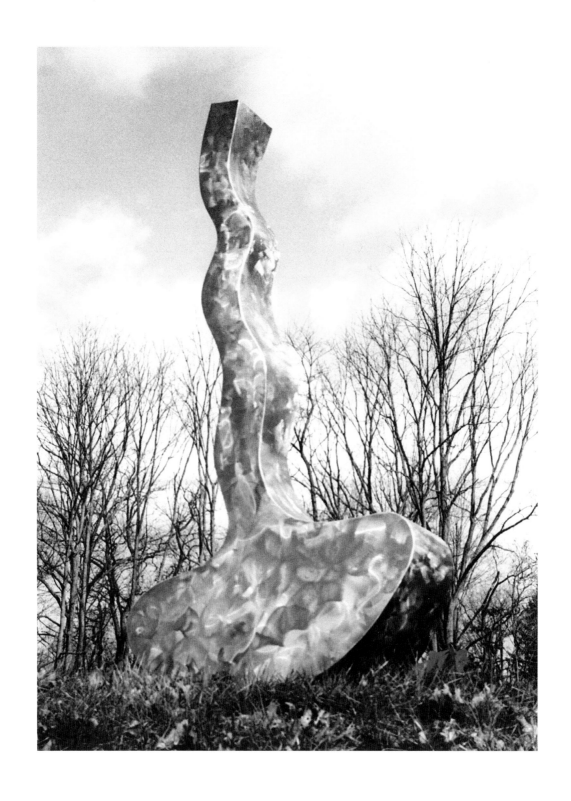

#0102 • "Rocker" 1998 • Stainless Steel • 96" H x 48" W x 12" D

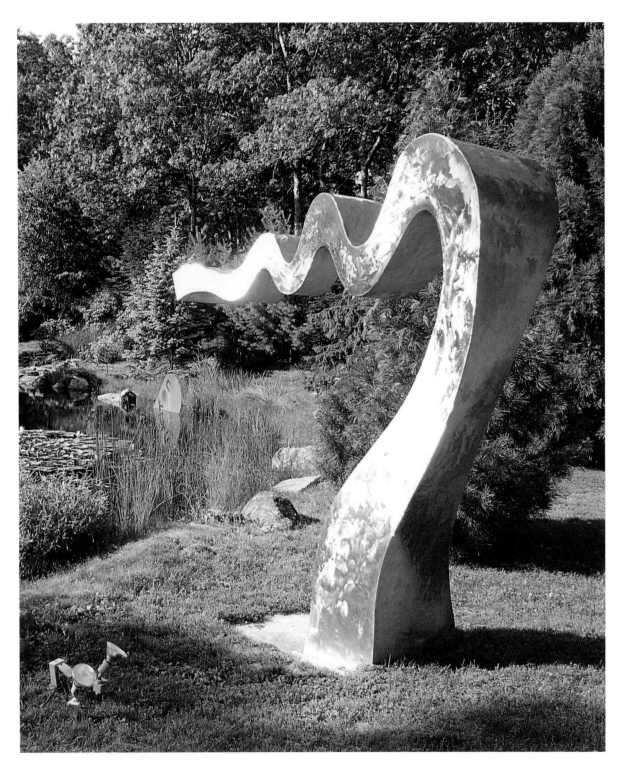

#0103 • "Stella in the Wind" 1997 Stainless Steel 120" H x 96"W x 28" D

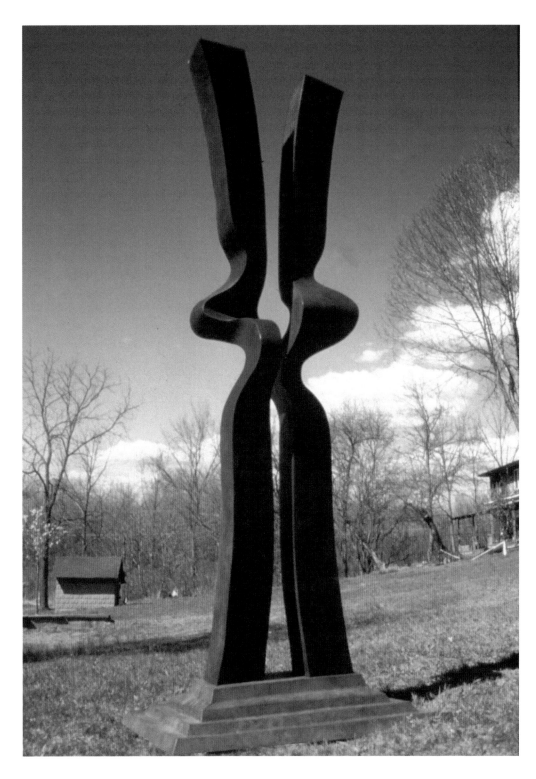

#0109 • "Itzamna Stella" 1996 Bronze 177" H x 49" W x 32" D

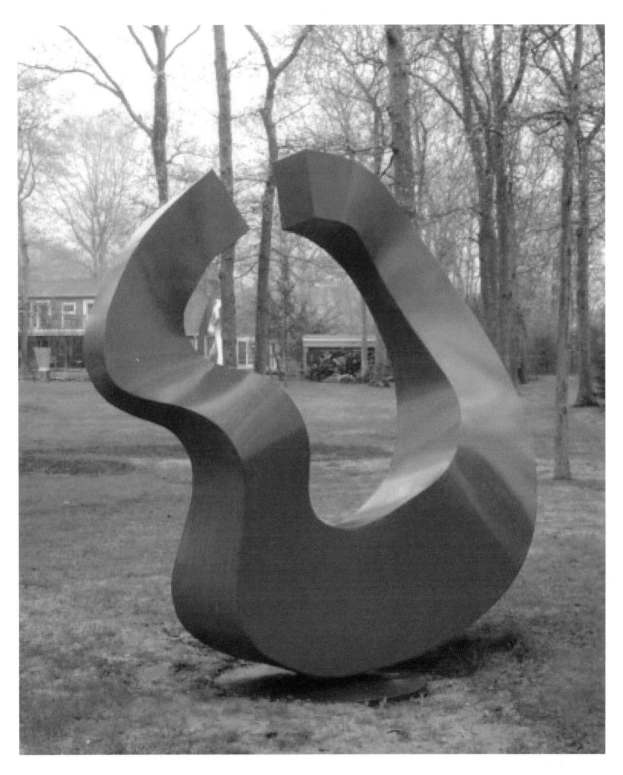

#0114 • "Big Red Gateway 2" 1986 • Painted Aluminum • 120" Diameter

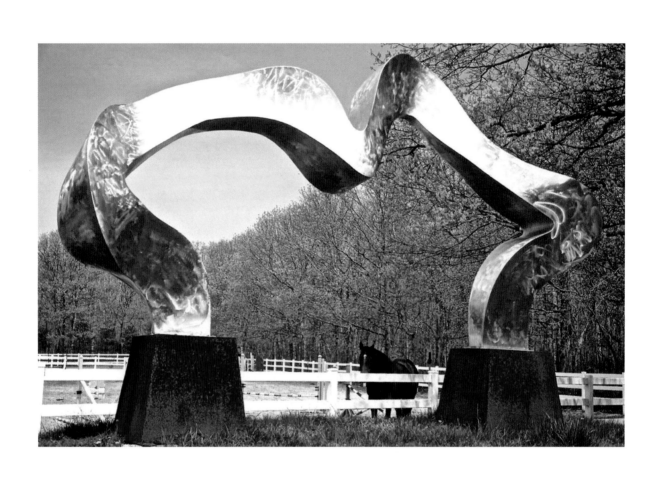

#0116 • "Undulation" 1974 • Stainless Steel 120" H x 216" W

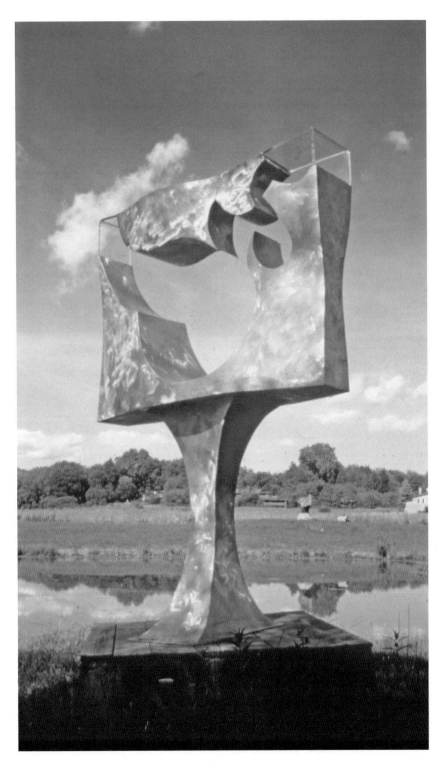

#0118 • "Floating Figure" 1972 Aluminum, Bronze and Plexiglass 96" H x 48" W x 24" D

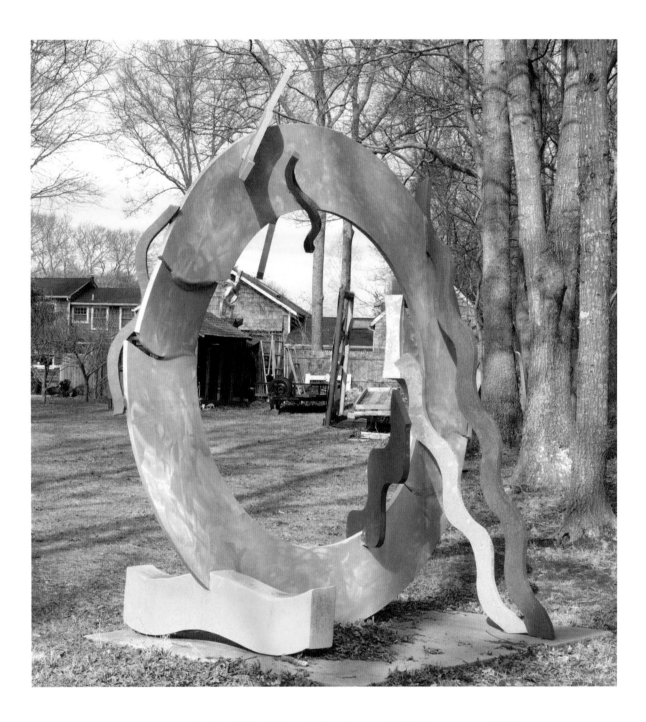

#0144 • "Big Ring" 1987 • Painted Aluminum 108" Diameter x 36" Deep

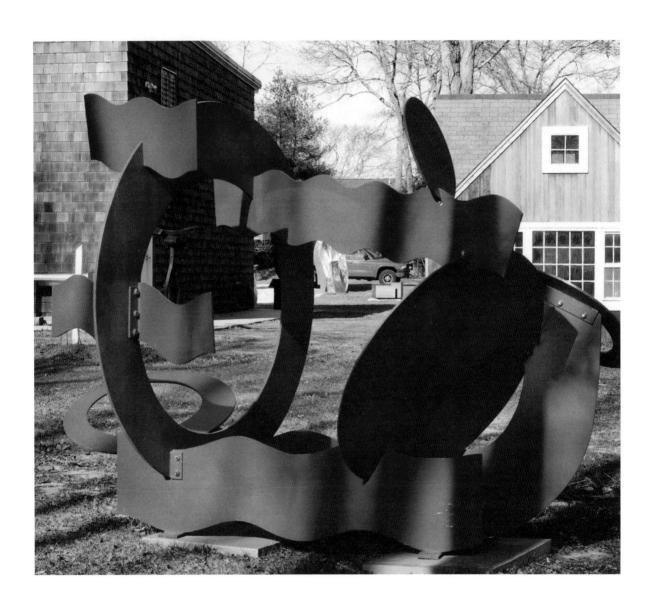

#0145 • "Circles and Waves XX" 1981 • Red Painted Steel 120"H x 192"W x 108"D

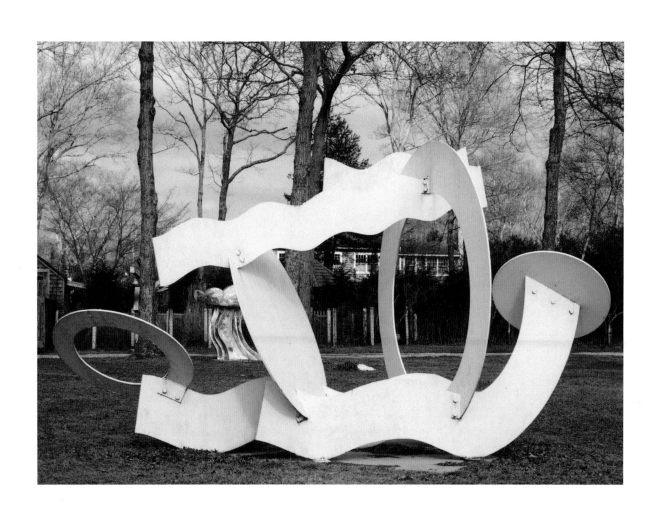

#0146 • "Circles and Waves XXV" 1988 • Painted Steel 120"H × 180"W × 108"D

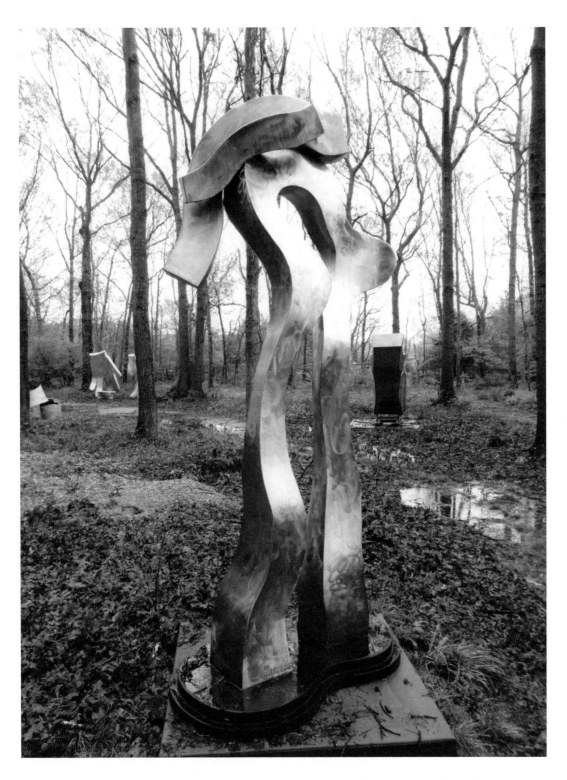

#0176 • "Dance" 2002/2012 • Stainless Steel 84" H x 36" W x 20" D

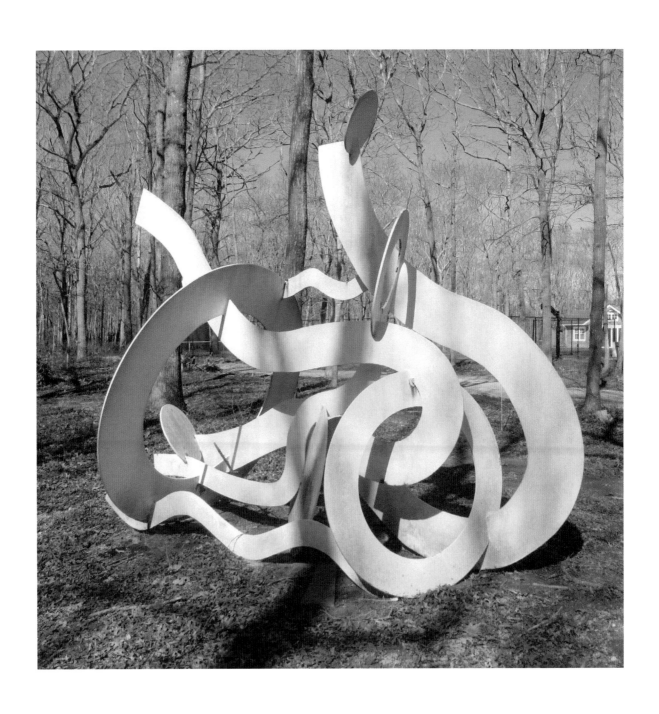

#0189 • "Montauk Sun & Moon" 1986 • Painted Steel 132"H x 144"W x 84"D

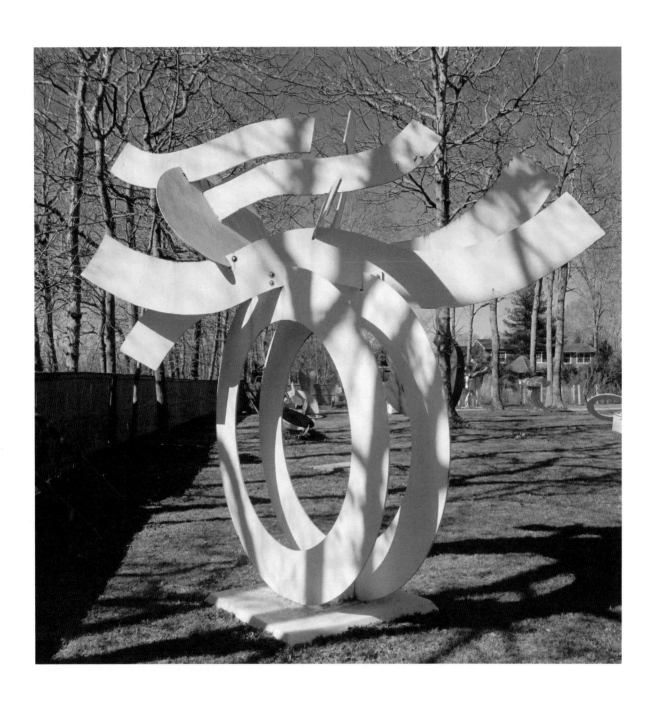

#0190 • "Haverstraw" 1986 • Painted Steel 156"H x 144"W x 84"D

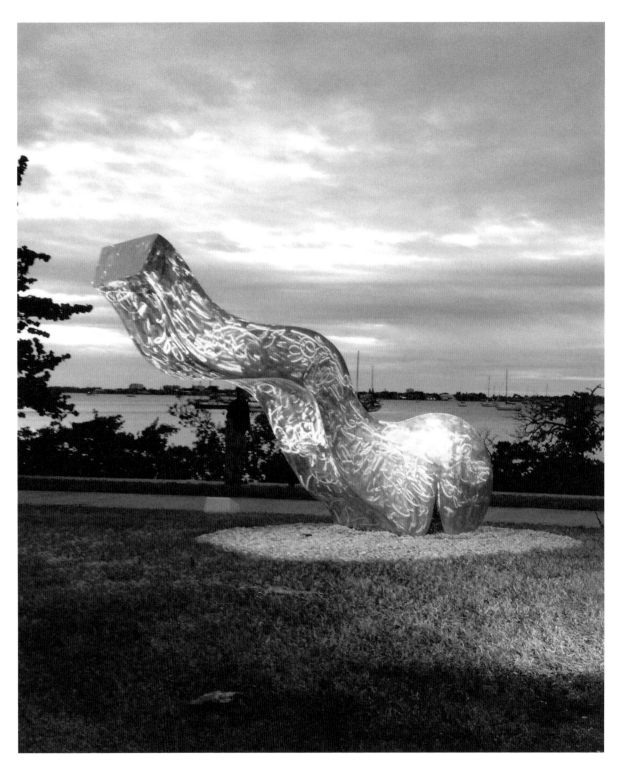

#0192 • "Elephant Heart" 2011 • Stainless Steel • 72" H x 96" W x 45" D

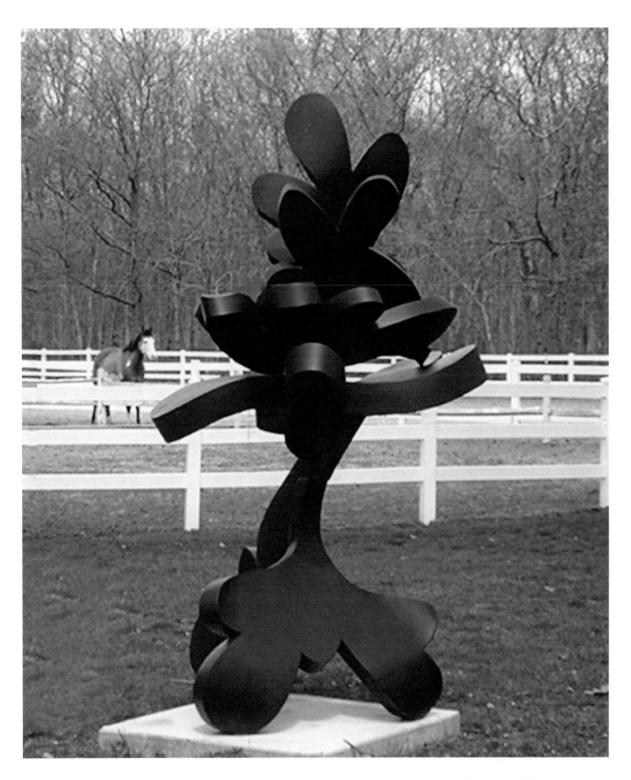

#0258 • "Black Flower" 2008 • Painted Stainless Steel 96" H x 72" W x 60" D

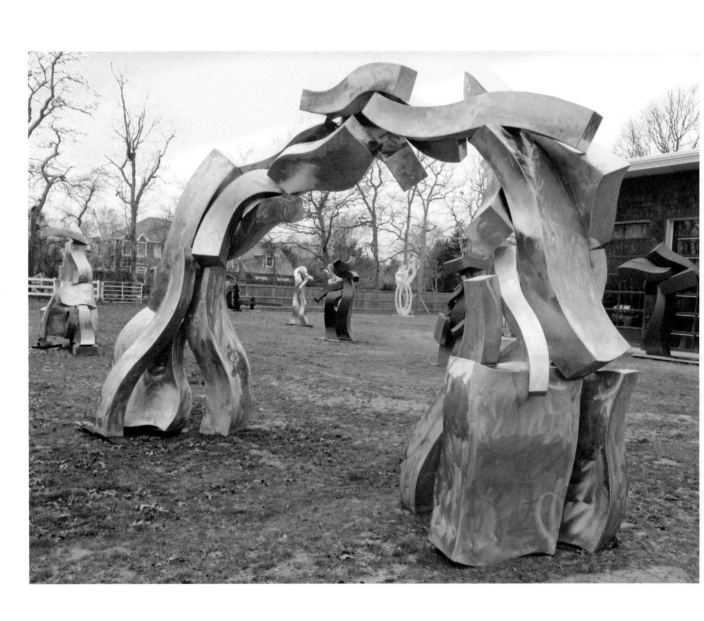

#0198 • "Sagg Portal #8" Stainless Steel 2011 144" H x 240" W x 60" D

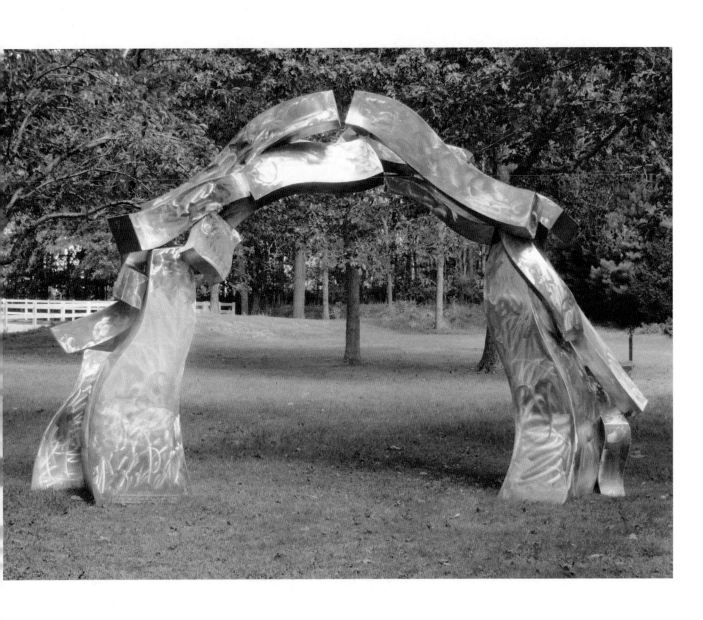

#0199 • "Sagg Portal #9" Stainless Steel 2011 138" H x 216" W x 48" D

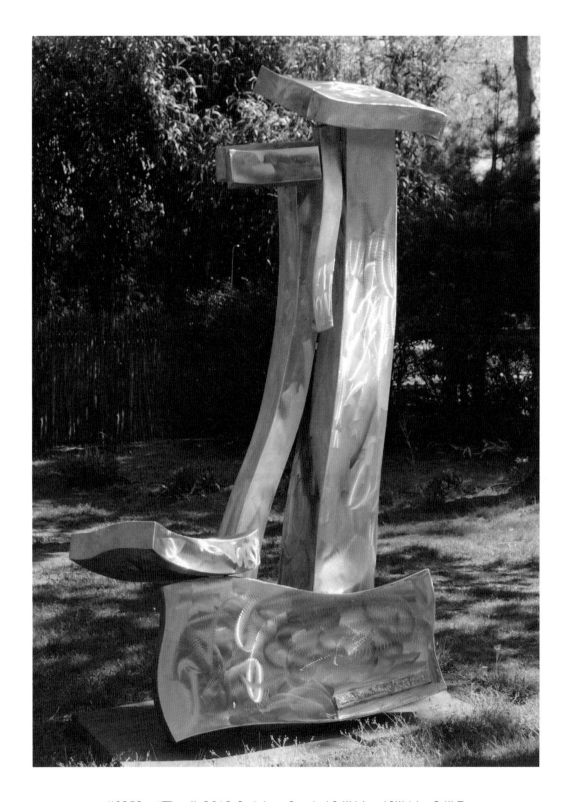

#0253 • "Thor" 2013 Stainless Steel 104" H x 60" W x 34" D

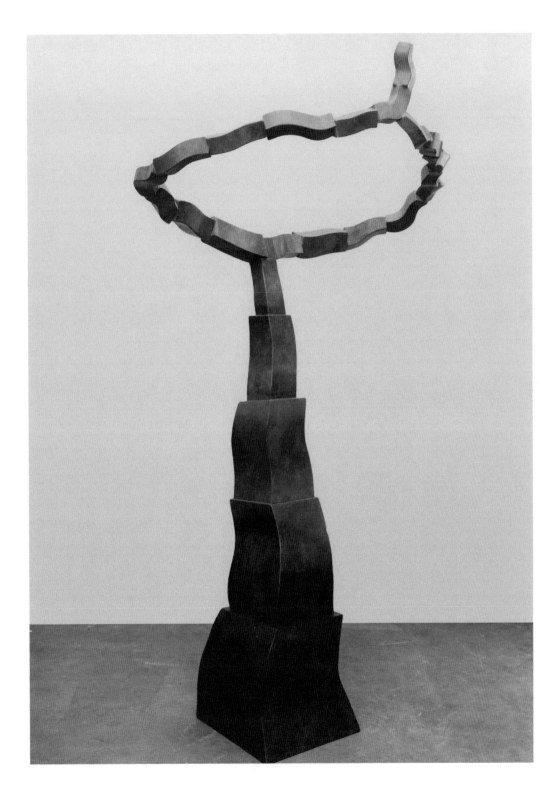

#0254 • "Gabrielle" 2013 Bronze Multi Patina 96" H x 52"W x 39" D

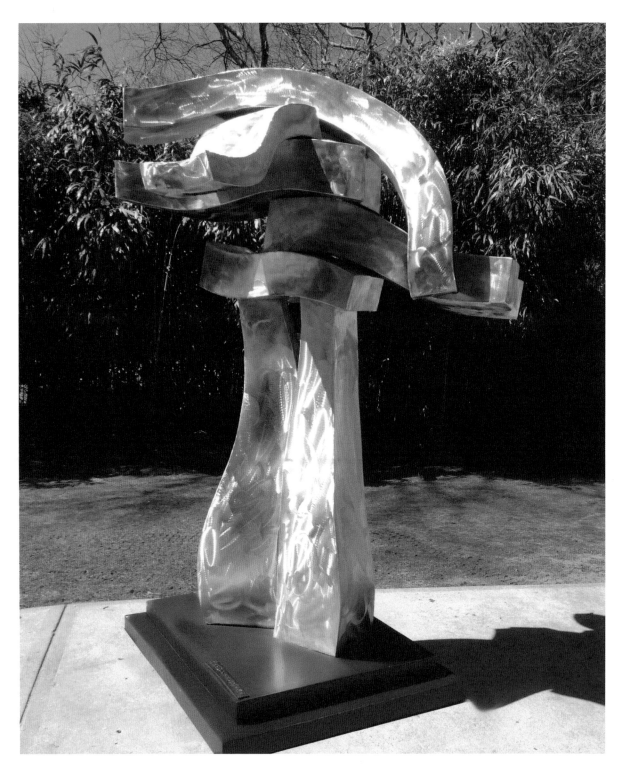

#0255 • "Peleus" Stainless Steel 2012 104" H × 55" W × 46" D

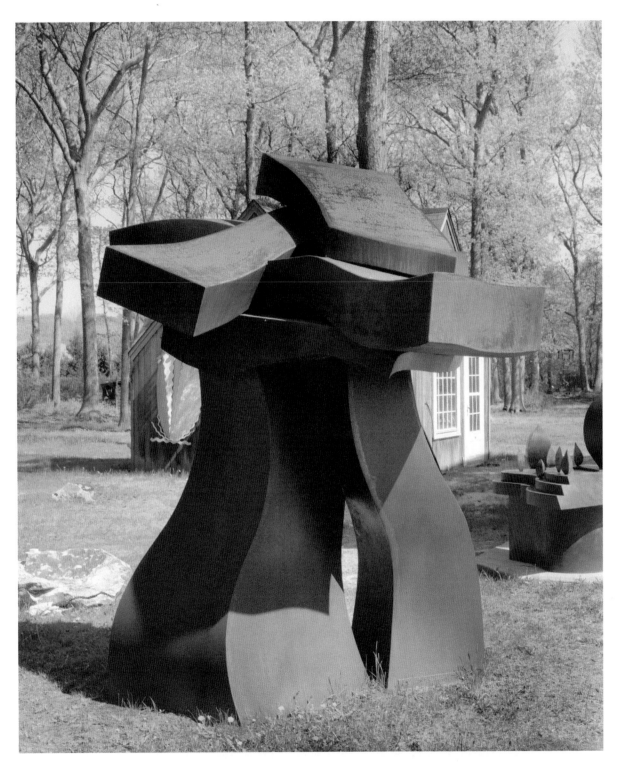

#0257 • Brown Menhir 2012 Corten Steel 104'' H x 60''W x 34''D

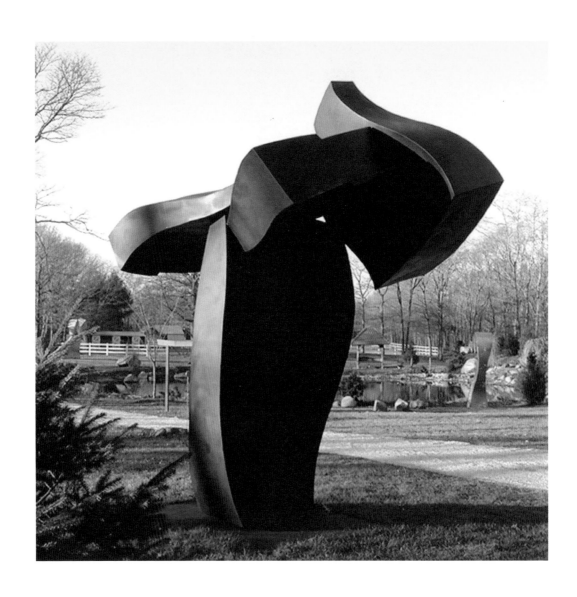

#0062 • "Guardiian's Grace" 2006 Bronze 120" H x 72"W x 60"D

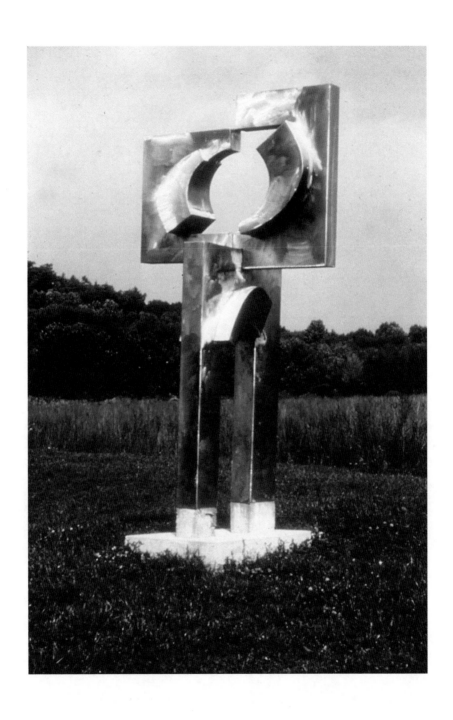

#0063 •"Genesis XIII" 1968 Stainless Steel 120"H x 48"W x 60"D

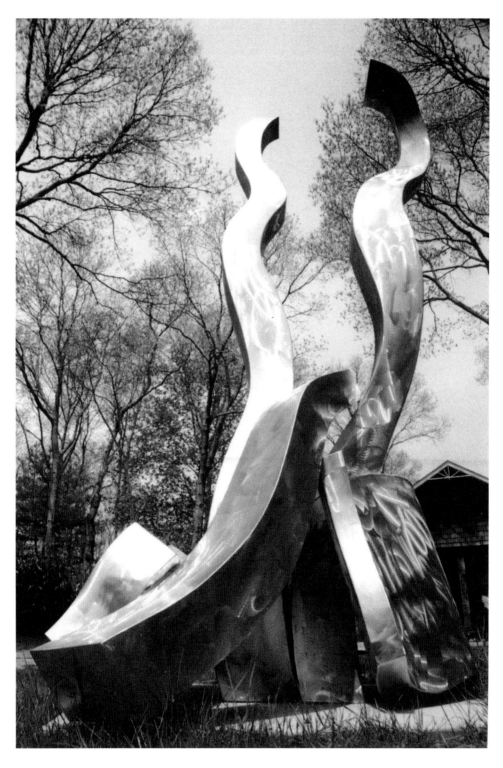

#0069 • "Family Outing" 2005 Stainless Steel 180" H X 72" Diameter

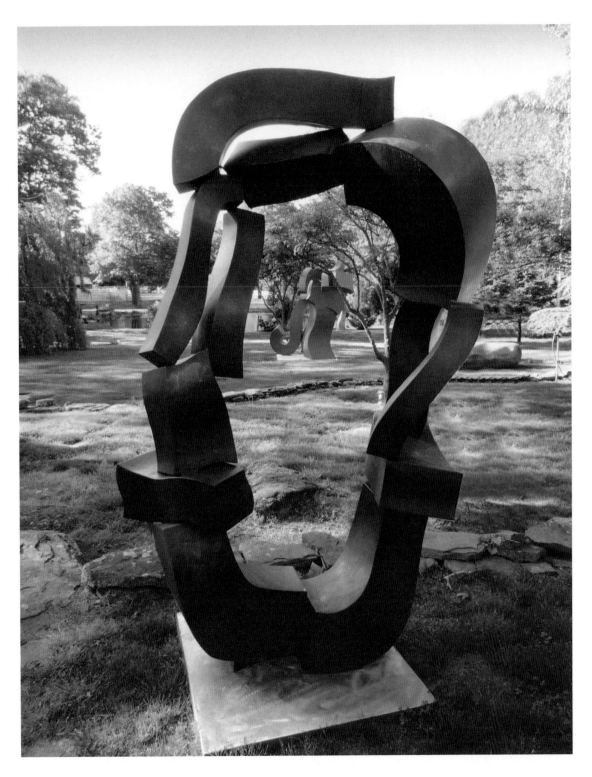

#0015 • "Oracle" 2007 Bronze 96"H x 60"W x 24"D

Fountains

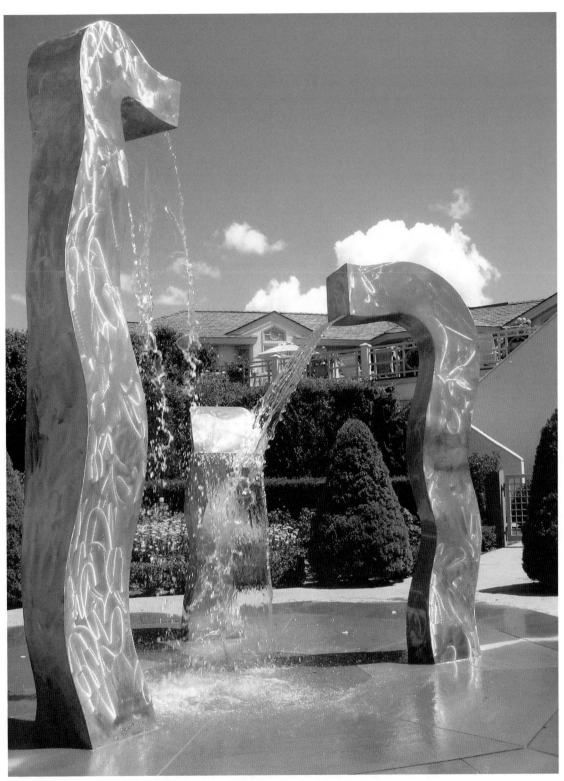

"Fiddlehead Fountain" 2006 Stainless Steel 12' x 12' diameter
Collection of Karen and Harvey Silverman Wainscott, NY

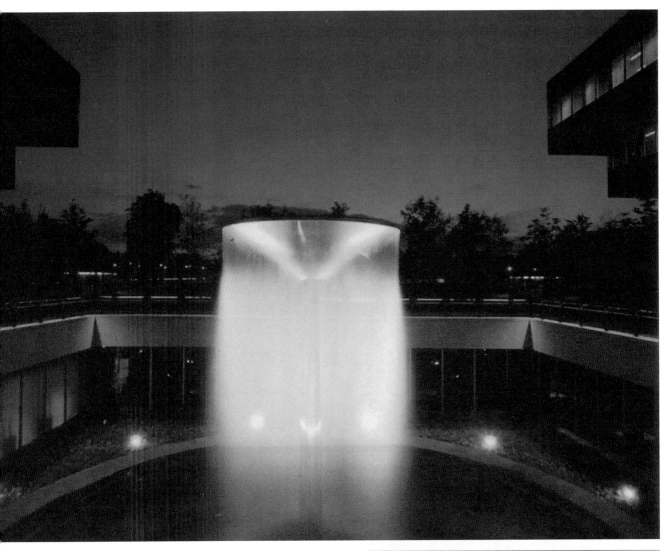

"Champagne Fountain" 1978
24' x 14' diameter
State Capital Plaza
Landsing, Michigan

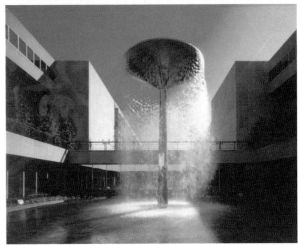

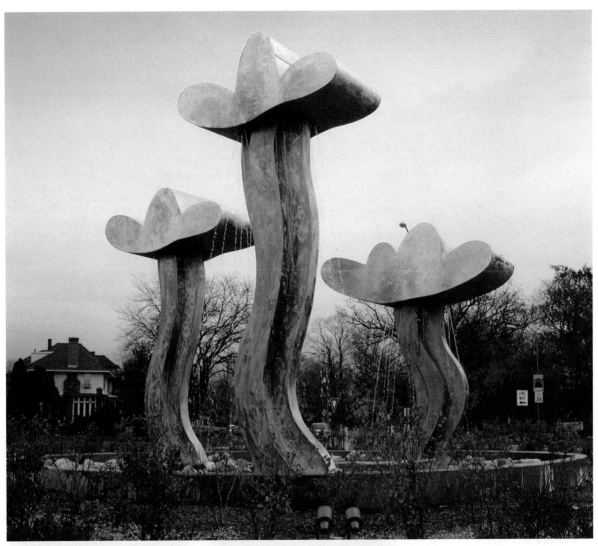

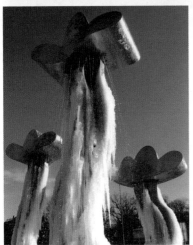

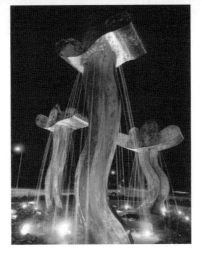

"Clouds" 2000
25' x 30'
Collection of the City of Toledo
Toledo, OH

57

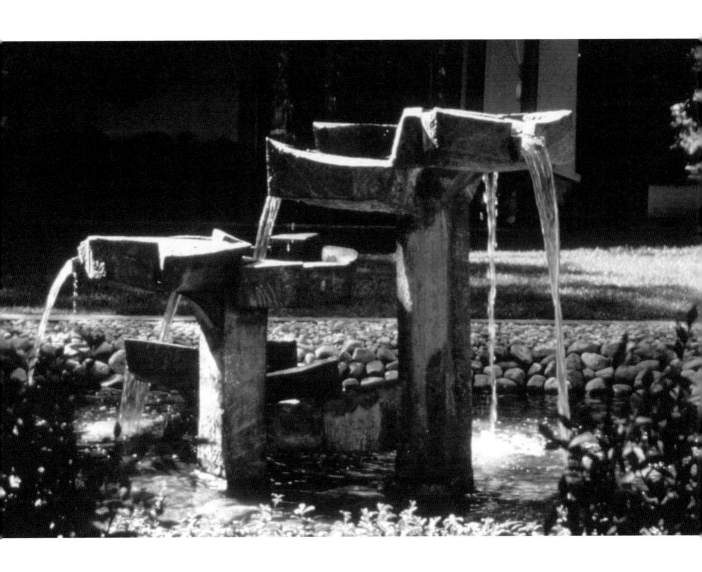

"Frederick Mayer Foundation" 1996 9' x 18' x 10' Denver, CO

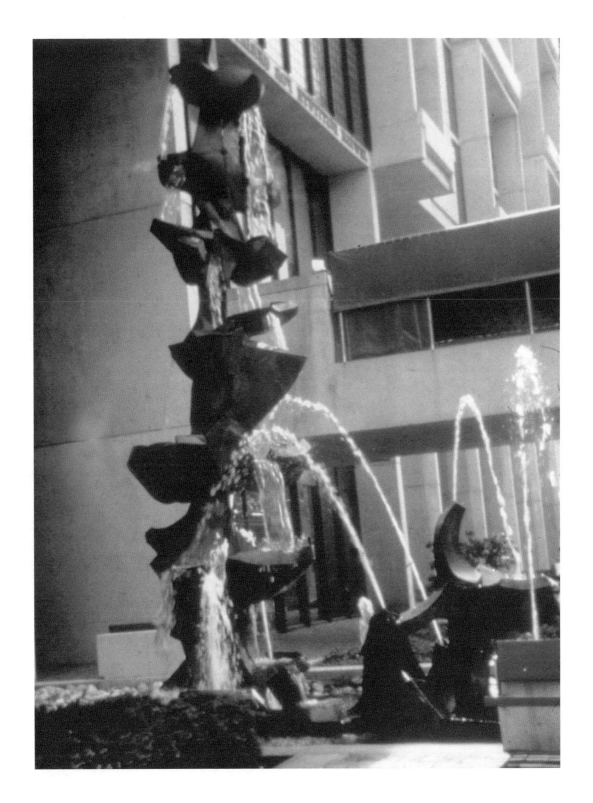

"Tower Falls" 1976 30' x 22' Jewish Center for Geriatric Care, Lake Success, NY

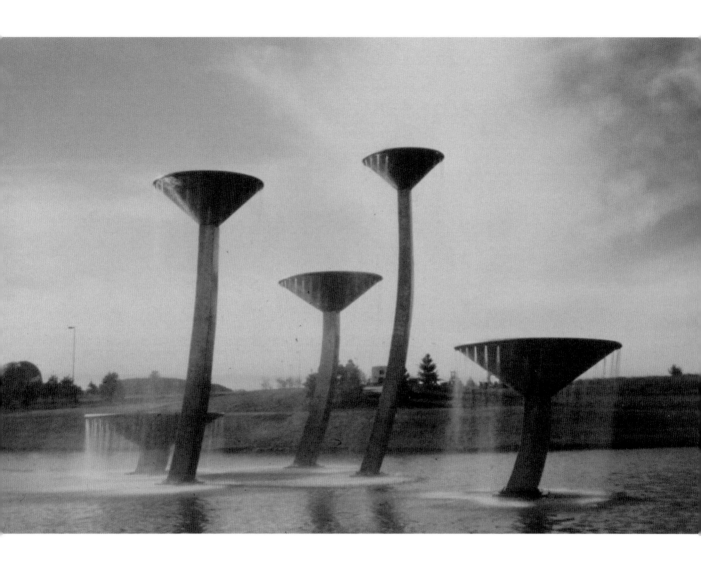

"Spring Mist" 1988 30' Tall Itasca, IL

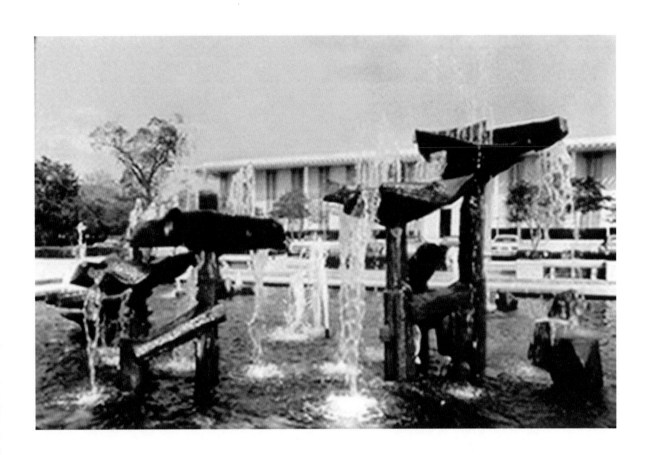

"Mushroom Water Garden" 1966 12' x 60' x 60' Levitt Headquarters Lake Success, NY

"Table Rock" Copper Fountain 1999 48" × 48" × 60" Private Collection

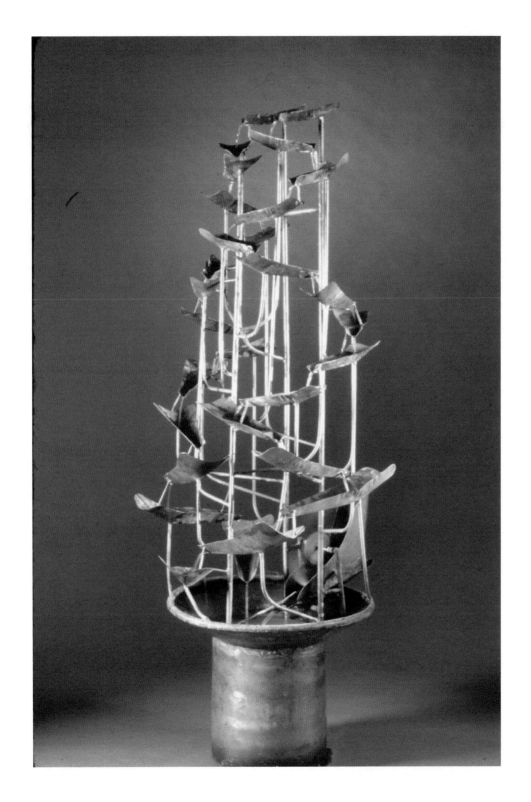

"Waterwheel" 2000 Copper/Brass Fountain 72" x 36" Diameter Private Collection

Public & Private Commissions

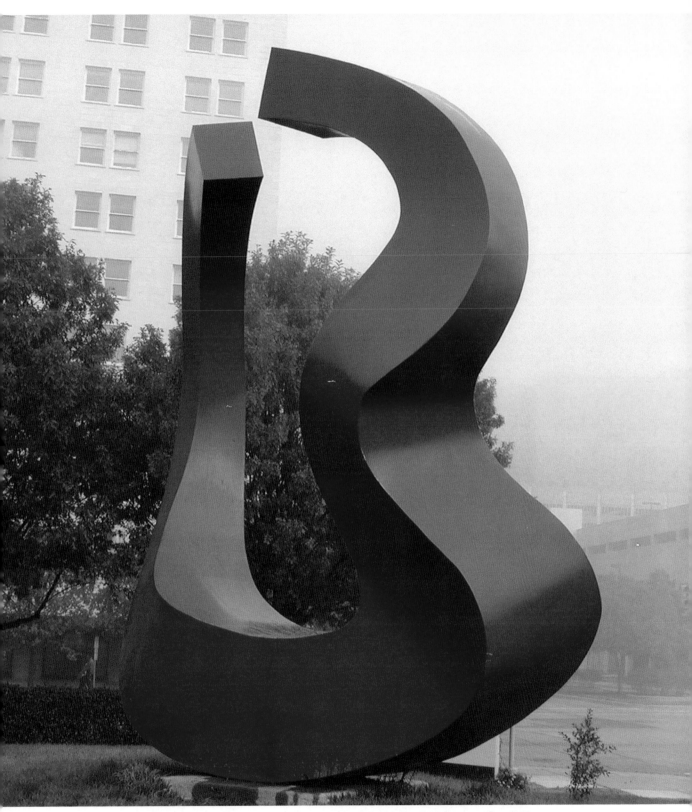

"Red Gateway" 1986 16' diameter Myriad Gardens Oklahoma, City, OK

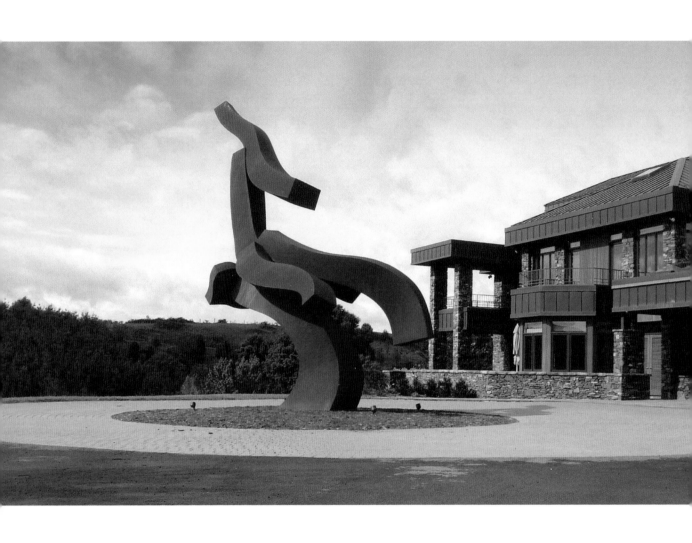

"Flight" 2005 27' x 25' diameter collection of R.J. Kirk Roanoke, VA

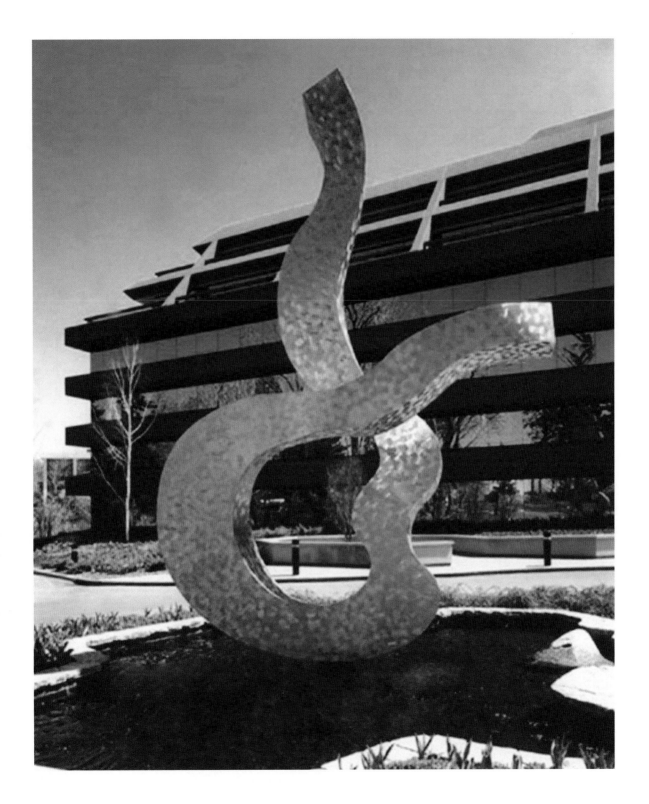

Crescendo 1984 24' x 16' x 6' Tarrytown, NY

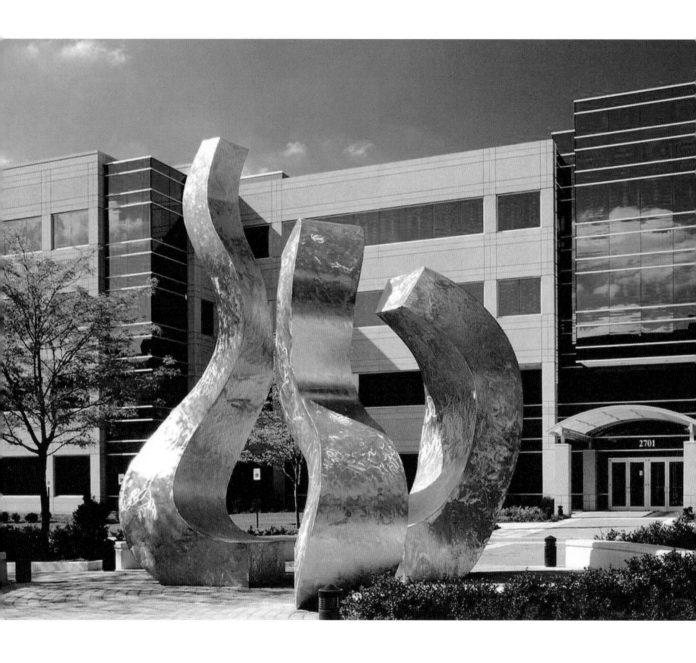

"Trinity" 2001 26' x 24' stainless steel Collection of Corporate Office Properties Columbia, MD

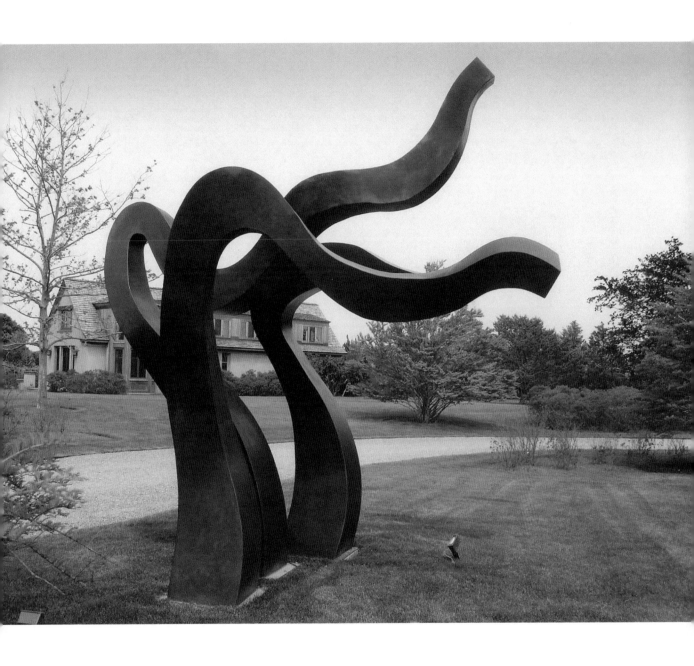

"Stella in the Wind" 2007 12' x 15' x 15' Collection of Diane and Tom Tuft Bridgehampton, NY

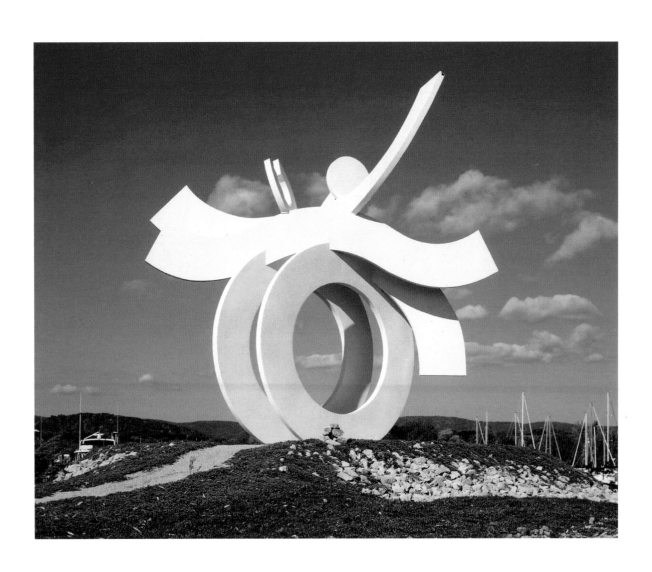

"Mariner's Gateway" 1986 35' x 34' x 12' Haverstraw, NY

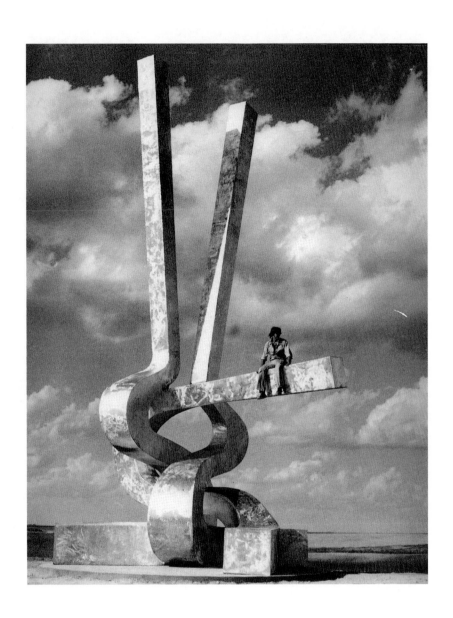

"Confluence" 1976 30' x 22' Sidney, NE

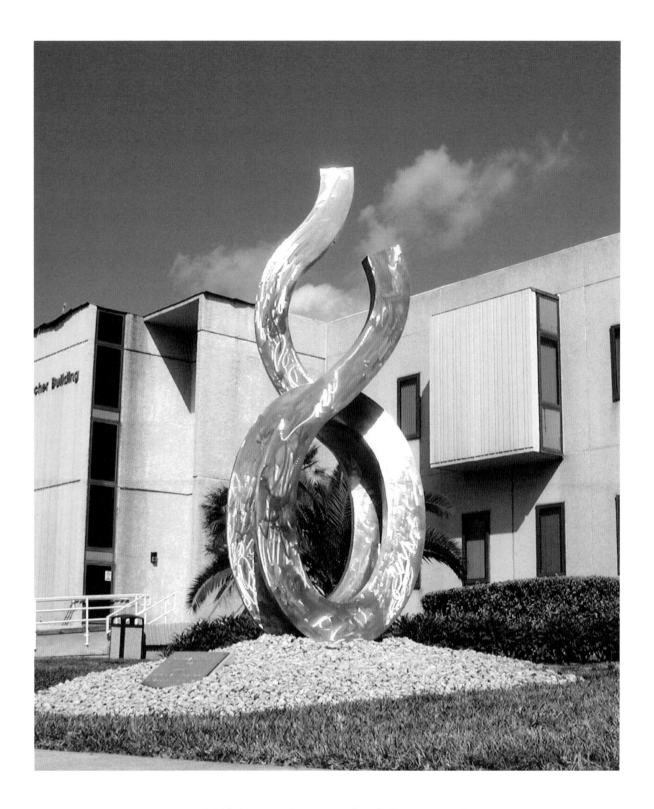

"Menos" 2008 Stainless Steel 14' x 8' x 3' Collection of Miami

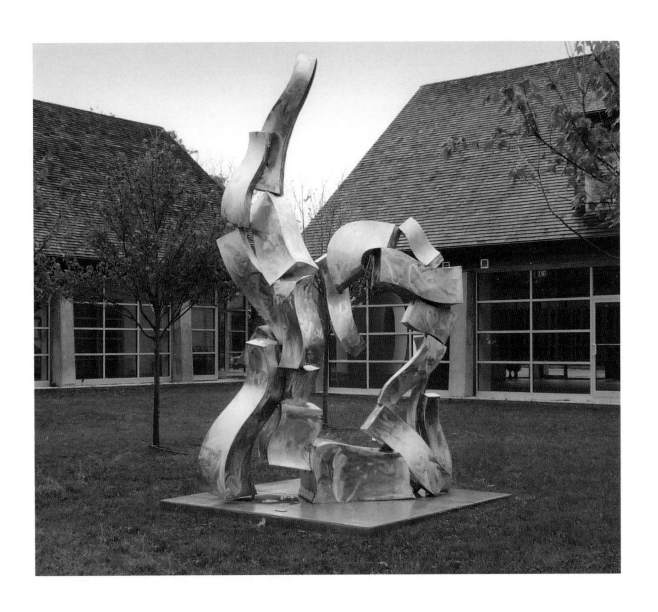

"Green Thunder" 2008 Stainless Steel 14' x 8' x 3' Collection of Louis and Susan Meisel Watermill, NY

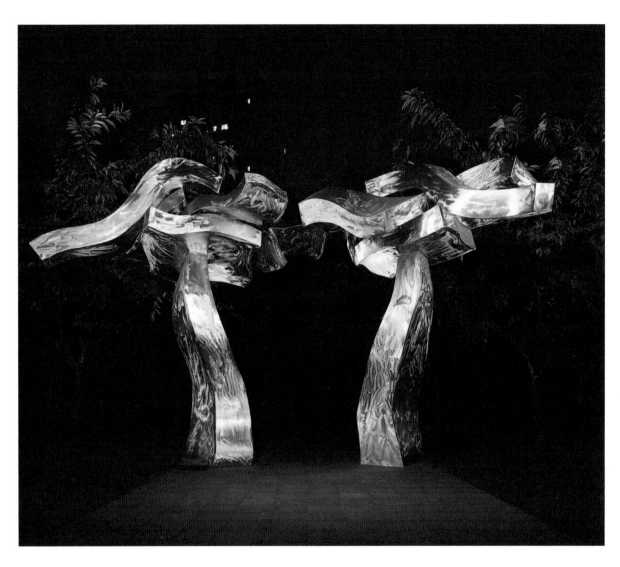

"Shanghai Portal" 2010
12' H x 22' W x 6'D
Jing'an Sculpture Park
Collection of the
City of Shanghai, China

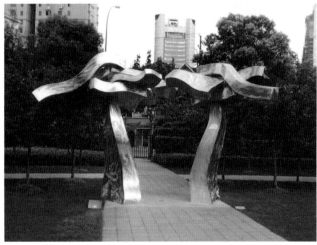

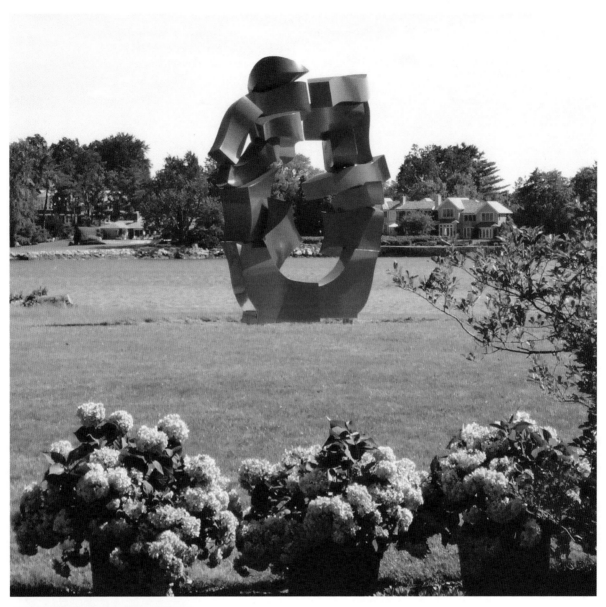

"Long Island Sound Portal" 2012
Painted Stainless Steel 12'H x 4'W x 8'D
Greenwich CT

Gates

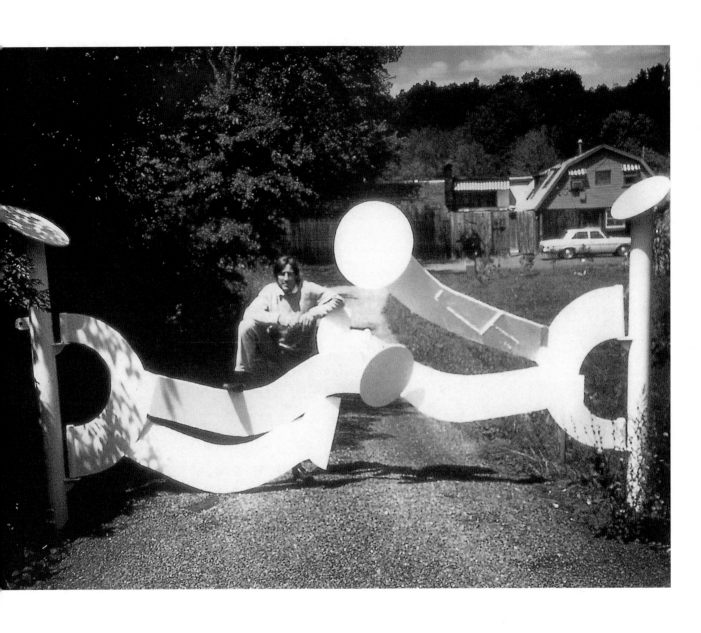

"Hans at Gate" 1986 Painted Stainless Steel Tillson, NY

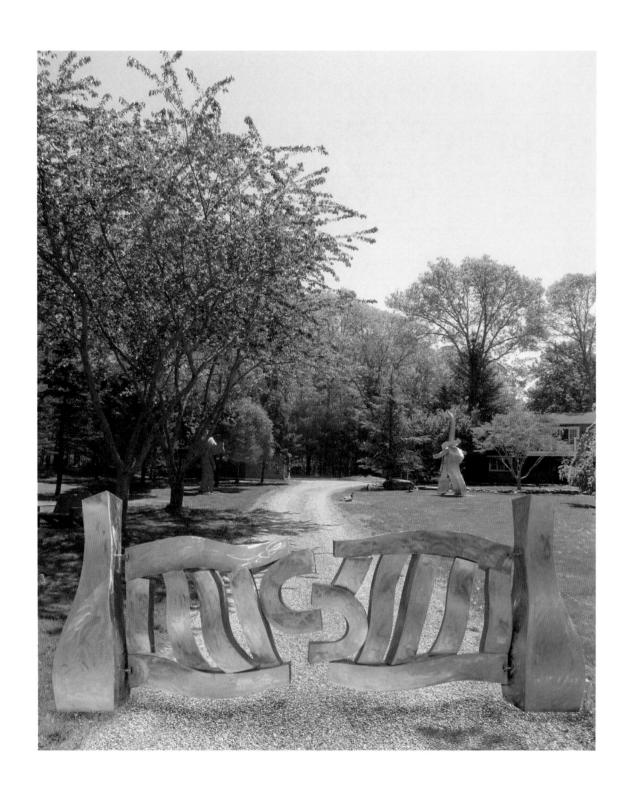

"Menhir Passage Gate" 2015 Stainless Steel

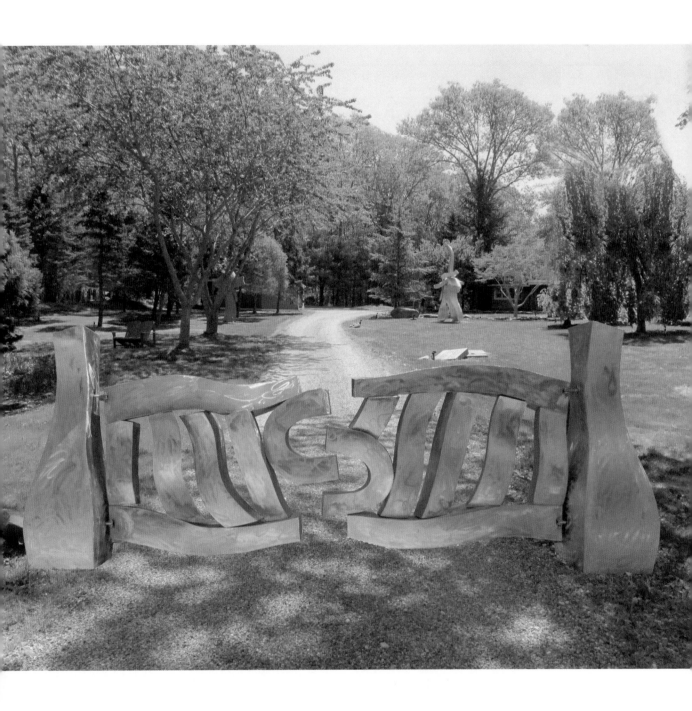

"Menhir Passage Gate" 2015 280" x 96" x 38" Stainless Steel
Artists' Personal Collection Sagaponck, NY

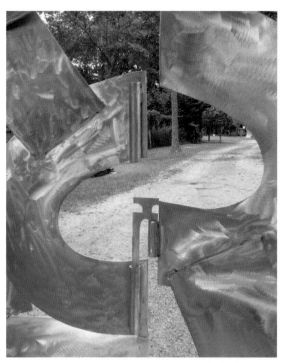

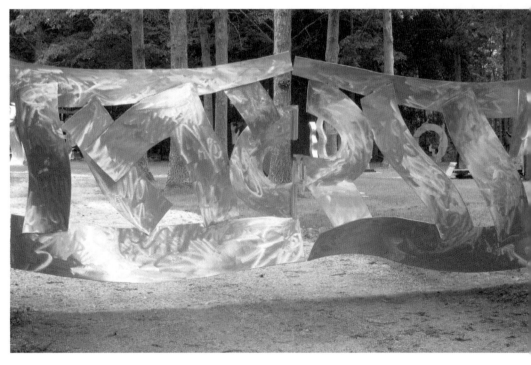

"Sagaponack Gate" Detail 2014 Stainless Steel

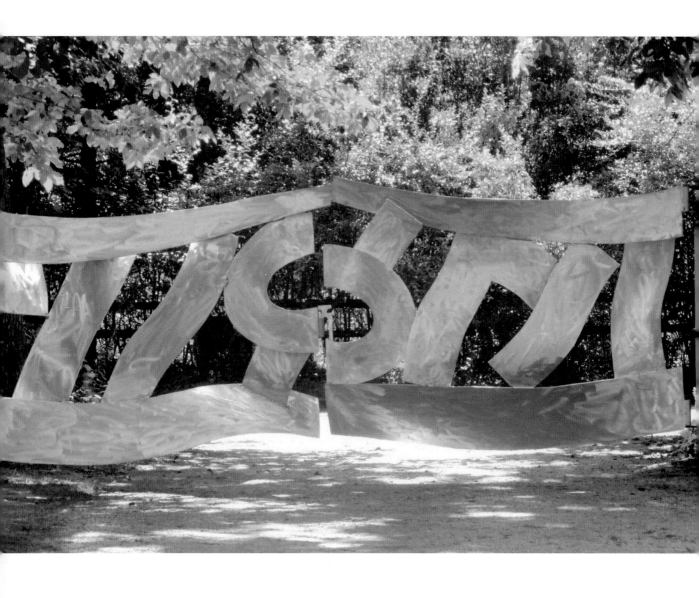

"Sagaponack Gate" 2014 24' x 7' x 1' Stainless Steel
Artists' Personal Collection Sagaponck, NY

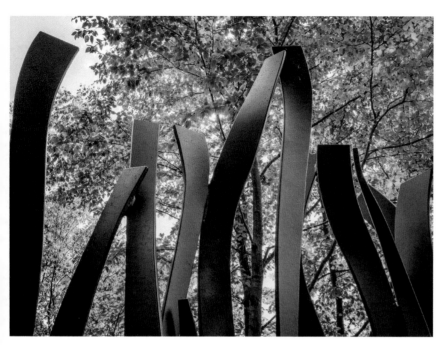

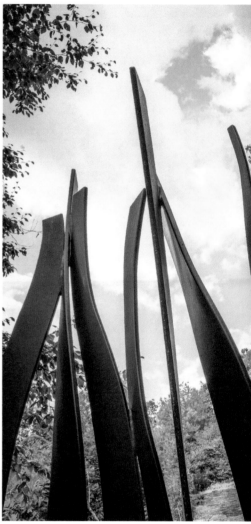

"Grass in the Wind" Detail 2013 Painted Stainless Steel • Brown

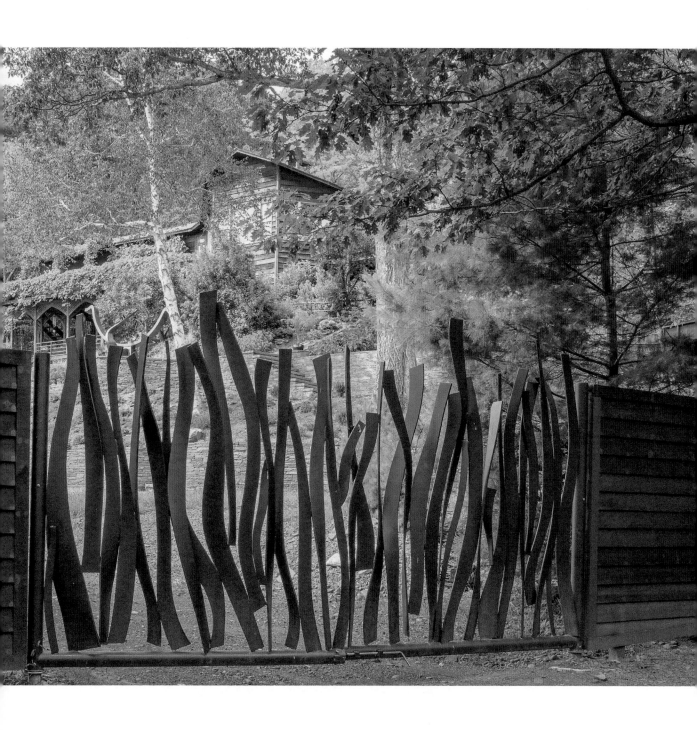

"Grass in the Wind" 2013 24' x 7' x 1' Painted Stainless Steel
Commisioned by Alan & Annie Sussman Woodstock, NY

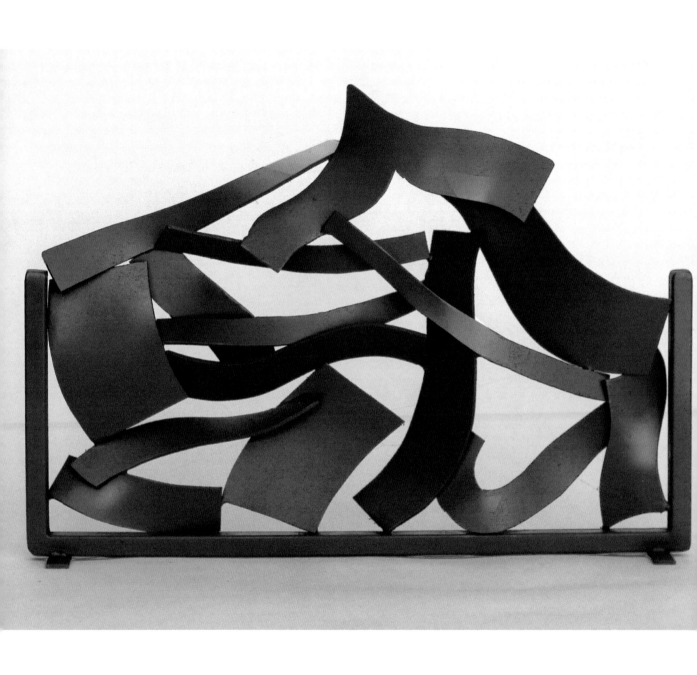

"Gate Concept" Model 2013 Painted Stainless Steel • Green

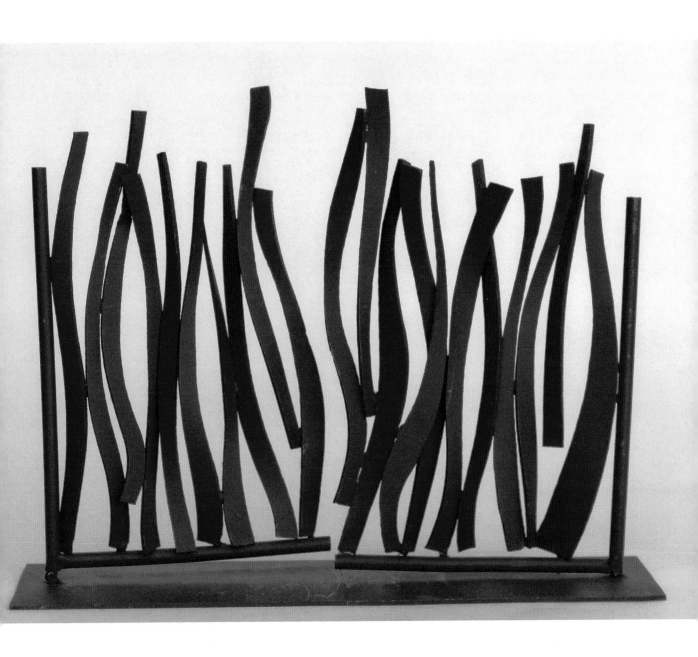

"Grass in the Wind" Model 2013 24' x 7' x 1' Painted Stainless Steel
Commisioned by Alan & Annie Sussman Woodstock, NY

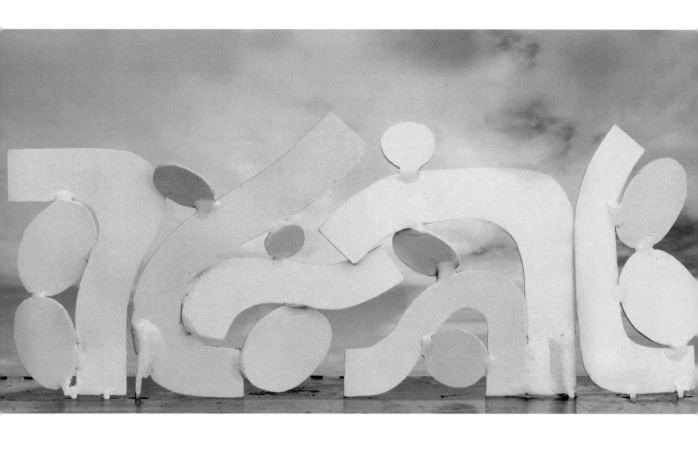

"Circles & Waves Gate Concept" Model 2013 Painted Stainless Steel • White

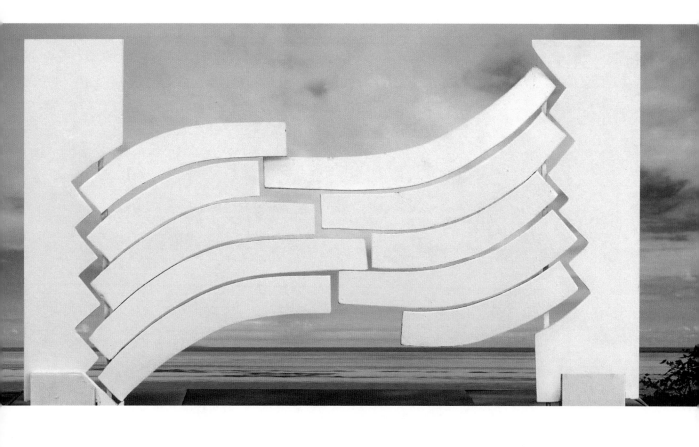

"Waves Gate Concept" Model 2013 Painted Stainless Steel • White

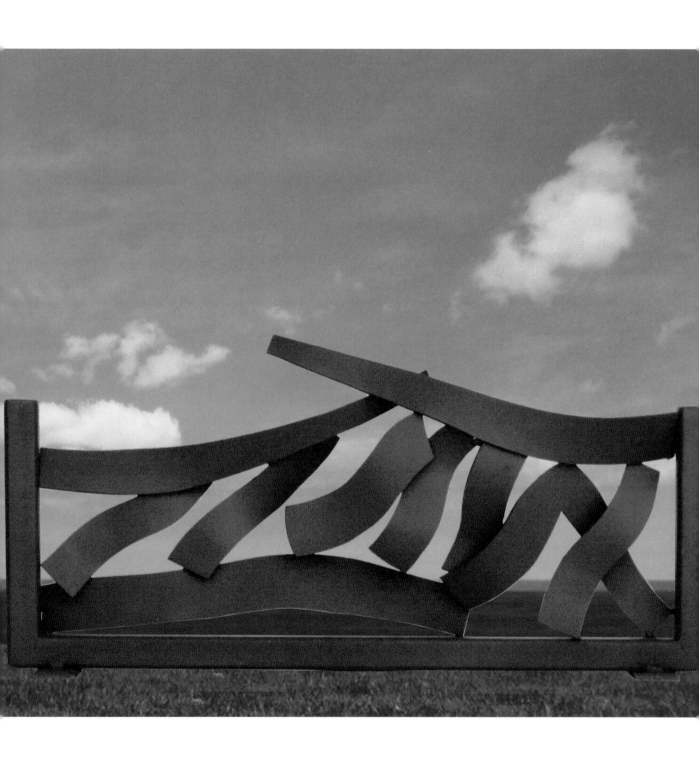

"Gate Concept" Model 2013 Painted Stainless Steel • Brown

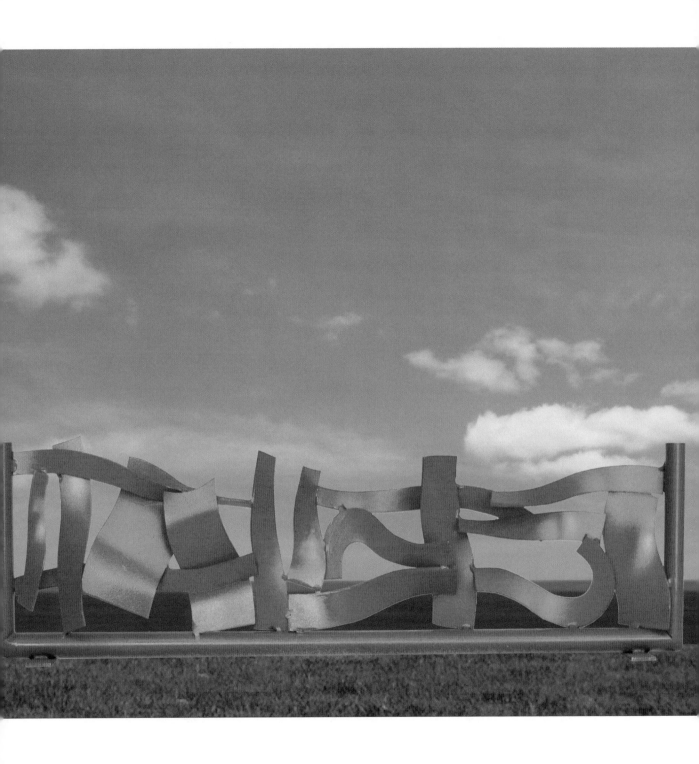

"Gate Concept" Model 2013 Painted Stainless Steel • Red

BRIEF BIO

Hans Van de Bovenkamp is an architectural designer and a sculptor. He has earned an international reputation over the past 50 years for designing, fabricating, installing and maintaining unique sculptures and fountains in collaboration with architects and designers. His works can be seen in public, civic, corporate and private collections. He has executed over 100 commissions.

ARTIST STATEMENT

"For me, making sculpture is both a spiritual and an artistic act. The studio is my playground, my laboratory, my sanctuary, where I practice and experiment with sculptural ideas. When I am working I am truly living in the present moment: focused and aware of choices as I make them, functioning in an elevated state between the conscious and the subconscience. Over time, I have been fortunate to gather together enough skill and vision to realize my ideas as they have come into my heart. Art for me is a way of life, not just a passion."

Selected Solo Exhibitions

2013	Adelphi University, Garden City, NY
2013	Samuel Lynne Gallery, Dallas, Texas
2011	Louis Meisel Gallery, New York, New York
2011	Bernarducci Meisel Gallery, New York, New York
2008	Goldman Warehouse, Wynwood District, Florida
2007	Sculpturesite Gallery, San Francisco, California
2007	Basel Miami Art Fair, Goldman Warehouse, Miami, , Florida
2007	Basel Miami Art Fair, Gary Nader Fine Art, Miami, FL
2006	Danubiana Meulensteen Museum, Bratislava, Slovakia
2005-06	Grounds for Sculpture, Hamilton, New Jersey
2003	Louis Meisel Gallery, New York, New York
2003	Bernarducci Meisel Gallery, New York, New York
2003	Sagaponack Sculpture Fields, New York, New York
1996	Michener Museum, Doyles Town, Pennsylvania
1996	Camino Real Gallery, Boca Raton, Florida
1994	Quietude Gallery, East Brunswick, New Jersey
1993	Elaine Benson Gallery, Bridgehampton, New York
1992	Shidoni Contemporary Gallery, Tesuque, NM
1981	Tiffany's, New York, New York
1981	University of Missouri, Columbia, Missouri
1979	Sculpture Center, New York, New York
1976	Brooklyn Borough Hall, New York, New York
1976	Arnot Art Museum, Elmira, New York
1970	Jacksonville Children's Museum, Jacksonville, Florida
1968	10 Downtown, New York, New York
1965	Glassboro State College, Glassboro, New Jersey
1963	New York University, New York, New York
1961	University of Michigan, Ann Arbor, Michigan

Selected Group Exhibitions

2014	Philippe Staib Gallery, Taipei City, Taiwan
2014	Art Sarasota, Seafare, Sarasota, Florida
2013	Season of Sculpture, Sarasota Marine Park, Florida
2012	Mark Borghi Gallery, Bridgehampton, New York
2011	Art Fair, Shanghai, China
2011	Gary Nader, Miami, Florida
2009	Spanierman Gallery, East Hampton , NY
2009	ArtHampton, Bridgehampton , NY
2008	ArtHampton, Bridgehampton , NY
2007	40 Years of Central Park, Lincoln Center , NY, NY
2007	Pratt Institute, Brooklyn, NY
2005	Sculpturesite Gallery, San Francisco, CA
2000-04	City of Fort Lauderdale, Florida
2000-04	Arlene Bujese Gallery, East Hampton, New York
1996-11	Elena Zang, Woodstock, New York
1994-11	Cavalier Gallery, Greenwich, Connecticut
2003	Guild Hall Museum, East Hampton, New York
1999-09	Shidoni Contemporary Gallery, Tesuque, NM
1999	Long Beach Museum, Long Beach, New Jersey
1996	Stamford Museum, Stamford, Connecticut
1988-91	Shidoni Contemporary Gallery, Tesuque, NM
1988	Chicago Art Fair, Navy Pier, Chicago, Illinois
1987	Hudson River Museum, Sculptors Guild, Yonkers, NY
1984	Molly Barnes Gallery, Los Angeles, California
1982	Oakland Museum, Oakland, California
1969-99	Elaine Benson Gallery, Bridgehampton, New York
1978	PS1 Contemporary Art Museum, Long Island City, NY
1978	Nassau County Art Museum, Roslyn Harbor, NY
1978	The United States Mission, New York, New York
1977	National Academy of Design, New York, New York
1976	American Institute of Arts & Letters, NY, NY
1973-76	Storm King Art Center, Cornwall, New York
1970	University of Connecticut, Storrs, Connecticut
1969	New York Sculptors Guild, Bryant Park, NY, NY
1968	Loeb Student Center, New York University, NY, NY
1968	Stamford Museum, Stamford, Connecticut
1964	Contemporary Arts Museum, Houston, Texas

Awards
2003 - Best Sculpture Award, Guild Hall, East Hampton, NY
1996-04 - Listing, Who Is Who in American Art
1996 - Sanctuary Design Competition, Omega Holistic Health Institute, Rhinebeck, New York
1976 - Exhibition, American Institute Arts & Letters, NY, NY
1976 - Nebraska Bicentennial Sculpture Competition, Sydney, Nebraska
1964 - Emily Lowe Sculpture Award, New York, New York

Selected Corporate Collections
2011 Louis Meisel, Watermill, New York
2009 Manhattan House, New York, New York
2005 Stamford, Connecticut (9 Fiddleheads)
2001 Corporate Business Park, Columbia, Maryland
1995 Litwin Building, Wall Street, New York, New York
1995 Goldman Properties, 110 Greene Street, NY, NY
1993 Mayer Collection, Denver, Colorado
1992 Hyatt Regency, Paris, France
1990 Marina Village, Alameda, California
1988 Amli Realty Corporation, Chicago, Illinois
1986 Haverstraw Marina, Haverstraw, New York
1984 Christiania, Tarrytown, New York
1980 Litwin Building, 72nd & 2nd Ave., NY, NY
1977 Cargill, Minneapolis, Minnesota
1967 Gaslight Tower, Atlanta, Georgia
1966 Georgetown Plaza Building, New York, New York
1966 Levitt Headquarters, Lake Success, New York

Selected Major Commissions
1966 Mushroom Water Garden Copper 12' x 60
 Levitt Headquarters Lake Success, NY
1984 Crescendo 24' x 16' x 6' Tarrytown, NY
1986 Mariner's Gateway 35' x 34' x 12' Haverstraw, NY
1988 Spring Mist stainless steel 30' Itasca, IL
1991 Menos stainless steel 25' x 10' 6'
 Texas A&M university
2001 Trinity 26' x 24' stainless steel
 Corporate Office Properties Columbia, MD
2005 Flight bronze 27' x 25' diameter
 R.J. Kirk Roanoke, VA
2007 Stella in the Wind 2007 12' x 15' x 15'
 Bridgehampton, NY
2008 Green Thunder 14' x 8' x 3' Meisel Watermill, NY
2012 Long Island Sound Portal" painted bronze
 12' x 4' x 8' Greenwich CT

Museum Collections
Grounds for Sculpture, Hamilton, New Jersey
Danubiana Meulensteen Museum, Bratislava, Slovakia
Miami University Art Museum, Oxford, Ohio
Boca Raton Museum of Art, Boca Raton, Florida
Estate of Nelson Rockefeller, Kykuit, New York
Lowe Art Museum, Coral Gables, Florida
Butler Institute of American Art, Youngstown, Ohio

Municipal Collections
2011 Jing'an Park, Shanghai, China
2001 City of Toledo, Ohio
1999 Mt. Sinai Hospital, Miami, Florida
1992 Myriad Gardens, Oklahoma City, Oklahoma
1988 City of Ormond Beach, Florida
1988 City Hall, Voorhees, New Jersey
1983 State Capitol Plaza, Lansing, Michigan
1976 I-80 Nebraska Bicentennial, Sidney, Nebraska
1972 Jewish Institute for Geriatrics Care,
 Lake Success, New York

University Collections
City University of New York,
Staten Island Community College, New York, New York
Stony Brook University, Stony Brook, New York
Texas A&M University, College Station, Texas
Towson University Art Center, Towson, Maryland
University of Missouri, Columbia, Missouri
Wheeling Jesuit University, Wheeling, West Virginia

Gallery Representation

Baker Sponder Gallery
608 Banyan Trail
Boca Raton, FL 33431
561.241.3050
www.bakerspondergallery.com

Bernarducci.Meisel Gallery
37 west 57th Street
New York, New York
212.593.3757
www.bernarducci.meisel.gallery.com

Mark Borghi Fine Art
NEW YORK
52 E 76th Street,
New York, New York 10021
212.439.6425
BRIDGEHAMPTON
2426 Main Street,
Bridgehampton, New York 11932
631.537.7245
PALM BEACH
255 Worth Avenue
Palm Beach, Florida 33480
561.328.9504
www.borghi.org

Ron Cavalier Gallery
GREENWICH
405 Greenwich Avenue
Greenwich, Connecticut 06830
203.869.3664
NANTUCKET
34 Main Street
Nantucket, Massachusetts 02554
508.325.4405
www.cavaliergalleries.com

Louis K. Meisel Gallery
141 Prince Street
New York, New York 10012
212.677.1340
www.meiselgallery.com

Gary Nader Fine Art
62 NE 27th Street
Miami, FL 33137
305.576.0256
www.garynader.com

Philippe Staib Gallery
m50, 4-102 Moganshon Rd.
Shanghai, China
86 21 6298 0729
www.philippestaibgallery.com

Samuel Lynne Galleries
1105 Dragon Street
Dallas, TX 75207
214 965.9027
www.samuellynne.com

Sculpturesite, Inc.
23588 Arnold Drive
Sonoma, CA 95476
707.933.1300
www.sculpturesite.com

Vincent Vallarino Fine Art
120 East 65th Street
New York, NY 10021
212.628.0722
www.vallarinofineart.com

Elena Zang Gallery
3671 Route 212
Woodstock, NY 12407
845.679.5432
www.elenazang.com